Trades and Crafts in
Medieval Manuscripts

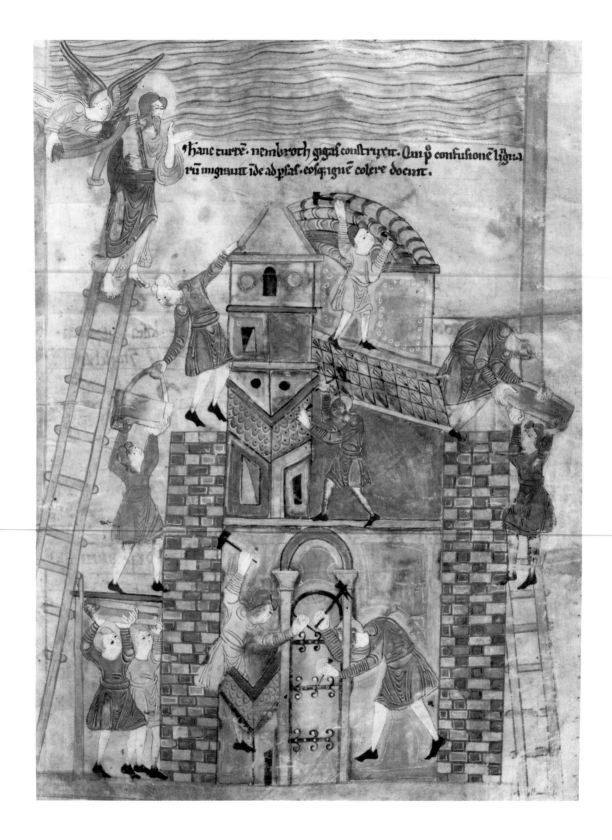

ˈhanc turrē. nembroth gigas construxit. Quiꝑ confusionē ligua
ꝛū migrauit ide ad psas. eosꝗ ignē colere docuit.

Trades and Crafts in Medieval Manuscripts

Patricia Basing

NEW AMSTERDAM

New York

Frontispiece: Building the Tower of
Babel.
Aelfric's Pentateuch. England; early 11th
century.
Cotton MS Claudius B IV, f. 19

© The British Library Board 1990

First published 1990 by The British Library, London

First published in the United States of America
in 1990 by

NEW AMSTERDAM BOOKS
by arrangement with The British Library

British Library Cataloguing in Publication Data
Basing, Patricia
 Trades and crafts in medieval manuscripts.
 1. European illuminated manuscripts. Illuminations.
 Special subjects: Industries & trades
 I. Title II. British Library
 745.6'7'094

 ISBN 1–56131–002–6

The Library of Congress Cataloging-in-Publication Data
is available

Designed by Andrew Shoolbred
Printed in England

Contents

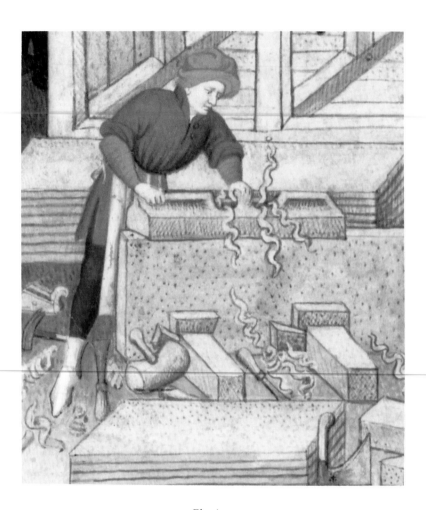

Planing.
Detail from PLATE VI.

Acknowledgements

I should like to thank the following for granting permission to reproduce illustrations from their manuscripts: the Museo Civico Medievale of Bologna for Fig. 23; the Master and Fellows of Trinity College, Cambridge, for Fig. 65 and the Bodleian Library, Oxford, for Fig. 53.

I am grateful to all those who have been so generous with their help and advice, including staff of the Department of Medieval and Later Antiquities at the British Museum and John Clark of the Museum of London. Thanks are also due to the authors of the many books I have consulted for information about particular manuscripts and on technical matters, which cannot be listed here.

Further, I am indebted to colleagues in The British Library, especially in Manuscript Collections, and in particular to Janet Backhouse, Michelle Brown and Scot McKendrick for sharing their knowledge of manuscript illumination, and to Ann Payne, who read my typescript. Finally, I would like to thank David Way and Anne Young of the Marketing and Publishing Office who have handled this project, Michael Boggan of the Manuscripts Photographic Service for his patience in dealing with my endless photographic requests, and the photographic staff of The British Library, without whose work this book could not have been produced.

Patricia Basing
London, September 1989

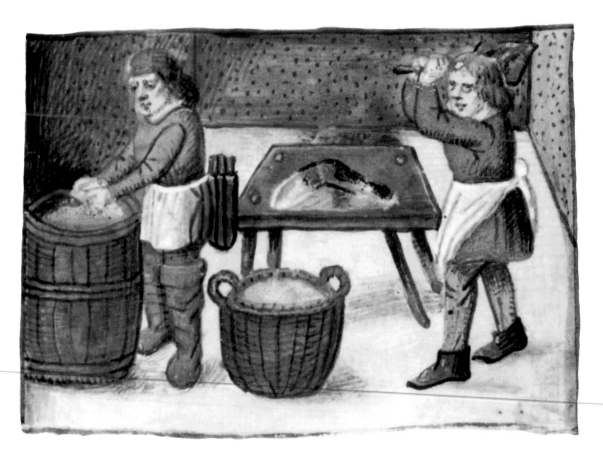

Butchers.
Detail from PLATE IX.

Introduction

Our knowledge of how people in the middle ages went about their daily life and work is obtained partly from the study of objects that have survived – like buildings, tools and domestic utensils – and from written texts and administrative records. Their activities are also illustrated in pictorial form, as in sculpture and carving in stone and wood, in wall and panel painting, decorated metal work, stained glass, tapestry and embroidery. Illuminations and drawings in manuscripts provide the most numerous group of illustrations, since a manuscript can contain more than 100 separate pictures: these illustrations are particularly attractive, as most of them are coloured.

Until the 13th century, illuminated manuscripts were usually produced in the monasteries; by that time, however, secular workshops had come into existence, and these workshops gradually replaced the monasteries as centres for manuscript illumination. Decoration of a manuscript, which can include borders, initial letters, marginal images and miniatures, was added after the text of a manuscript was complete. The word 'miniature', which may derive from the Latin word *miniare*, meaning to paint with red lead, is now employed to describe a picture in an illuminated manuscript. Therefore, although it is perhaps natural to think of a miniature as a small item, the term is also correctly used for illustrations that cover an entire page.

Text and illustration

Pictures in a medieval manuscript are usually related to the text of the volume in which they occur. The most important book in the middle ages was, of course, the Bible, and the Bible is essentially a story book. The stories were not only illustrated in the Bible itself, but in service books incorporating Biblical texts, such as the Psalter (the Book of Psalms), or the Lectionary, a collection of readings from scripture used by the clergy at Mass (*see* Fig. 55). The Harley Psalter, produced at Christ Church, Canterbury, in the early 11th century, contains numerous drawings, including agricultural scenes. An example from this manuscript (Fig. 1) shows the close relationship between

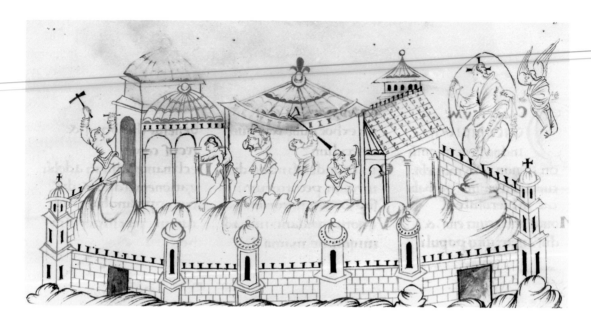

Fig. 1 Psalm 126, building scene.
Harley Psalter.
Canterbury; early 11th century.
Harley MS 603, f. 66 verso

text and picture: the building scene illustrates the adjacent text of Psalm 126, which begins 'Except the Lord build the house, they labour in vain that build it'. The Luttrell Psalter, an English manuscript produced before 1340 for Sir Geoffrey Luttrell of Irnham in Lincolnshire (*see* Figs 6, 17 and 20), contains the finest set of agricultural scenes in a medieval manuscript. However, while some of the Luttrell miniatures can be linked to words of the psalms occurring on the same page, the series as a whole probably reflects the seasonal cycle of work on Sir Geoffrey's estates. During the later middle ages, vernacular Bible Histories, translations of the Bible with added material (*see* Fig. 41), and Bible picture books, were produced. A unique manuscript, the Holkham Bible Picture Book, written and illuminated in England around 1320–30, contains over 200 illustrations relating to three themes, the Creation, the Gospel story, and the Last Judgement. Besides Cain labouring in the fields (*see* Fig. 3), other pictures include Adam digging, Eve spinning and the building of the ark.

Miniatures of the building of the Ark, and of another Biblical building theme, the Tower of Babel, occur in the

Bedford Hours, a beautifully illuminated Book of Hours produced in Paris for John, Duke of Bedford, brother of Henry V and Regent of France, and his wife, Anne of Burgundy, probably at the time of their marriage in 1423 (*see* PLATE VI, Fig. 40). The Book of Hours was a prayer book for private devotion, widely used by the laity in the 14th and 15th centuries. Like the more complex Divine Office said by the clergy, the Book of Hours contained prayers to be said at particular times of day. Apart from the Hours of the Blessed Virgin Mary, other prayers and short services were included, such as the Hours of the Holy Spirit, and the Office of the Dead (prayers said at the vigil over the corpse on the night before burial). Each section of an illuminated Book of Hours is usually introduced by an appropriate miniature; the Office of the Dead, for example, is often illustrated by a burial scene (*see* Fig. 58).

Like many other prayer books and liturgical manuscripts, the Book of Hours is usually preceded by a calendar, setting out the liturgical feasts for each month of the year. These calendars are often illustrated with miniatures showing the labours and pastimes of the changing seasons, called the Labours of the Month. As the term suggests, these pictures are an important source for illustrations of agricultural work and husbandry. The miniatures for each month follow a standard pattern: ploughing in spring or autumn, haymaking in June, reaping in July, treading grapes and winemaking in August or September and killing pigs in December.

In spite of the prominence of Biblical and other religious texts, nearly half of the pictures in this book have been taken from works of a secular nature. Sometimes a poem or story is illustrated, for example the *Georgics* of Virgil, or a version of the Romance of Alexander the Great. On other occasions, the pictures have a practical purpose; an obvious example is a work giving instruction, like a medical text book. Similarly, manuscripts of *Des profits ruraux des champs* are a source for illustrations of horticultural practice and rural occupations. This treatise is a French translation of a work on agriculture and husbandry, the *Liber Ruralium Commodorum* ('Book of rural expertise and practice'), compiled in the 13th century by Petrus de Crescentiis of Bologna (*see* PLATE II and Figs 10, 11 and 14).

Miniatures showing men and women at work occur in encyclopaedias, universal histories and collections of anecdotes. The encyclopaedia *Des Proprietez des Choses* ('On the properties of things') was a French translation of a Latin work by the 13th-century English writer Bartholomaeus Anglicus. In a copy of this text written and illuminated in Bruges in 1482, chapters on minerals, dyestuffs and the human body, for example, are preceded by miniatures showing people engaged in occupations associated with the subject matter (*see* Figs 32, 48 and 62). Another popular work was *Le livre des cleres et nobles femmes* ('The book concerning famous women'), a French translation of a Latin work by the 14th-century Italian poet and scholar Giovanni Boccaccio. The text is a collection of biographies of well-known women, both mythical and real. Illuminated manuscripts of the work show the women engaged in the activities for which they are celebrated (*see* Figs 45 and 61), and therefore illustrate women's labours, an aspect of medieval life which has often been overlooked. Women were constantly at work: the landowner's wife ran a large household; the peasant woman worked on the land, with the livestock and in the dairy; the craftsman's wife frequently carried on the family business if her husband died or became sick, and women are known to have worked as artists and scribes.

The representation of the author as scribe in European illumination occurs as early as the sixth century. In particular, manuscripts of the Gospels frequently show the Four Evangelists with writing materials, each at the beginning of the Gospel he composed, and as a consequence, illustrations of scribes at work are more common in early medieval manuscript illumination than pictures of other groups of craftsmen. The earliest example of Evangelist miniatures of this kind in a manuscript written in the British Isles occurs in the Lindisfarne Gospels, produced at the monastery on Lindisfarne Island at the end of the seventh century. An illustration of St Mark (Fig. 2) taken from a Gospel Book produced probably at the Court of the Emperor Charlemagne around 800, shows the Saint reaching up to his ink pot, conveniently situated on top of a pillar. In the later middle ages, the author or translator of a text sometimes appears in a miniature at the beginning of the manuscript,

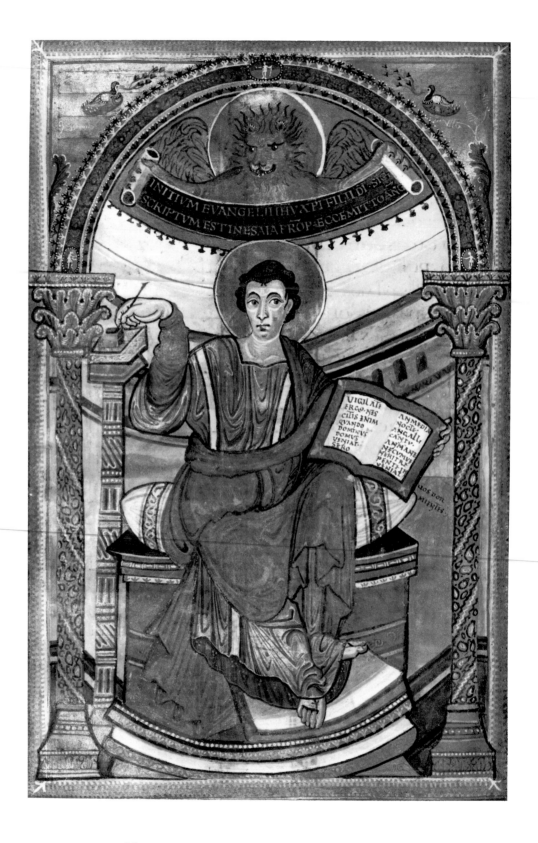

14

Fig. 2 St Mark writes his Gospel.
Harley Golden Gospels. Carolingian Court; about 800.
Harley MS 2788, f. 71 verso

either writing his work (*see* PLATE XIII) or presenting the book to a patron.

Finally, there is one type of manuscript illustration where the pictures are not usually related to the text; these are the marginal images found increasingly in manuscripts of the late 13th and 14th centuries. The themes of these illustrations are derived from many sources: religious and secular literature and legend, moral tales and scenes from everyday life, showing men and women at work and recreation. A notable example of a manuscript of this kind is the Smithfield Decretals (*see* Figs 22, 46 and 52). This legal text, a copy of the Decretals of Pope Gregory IX, was formerly owned by the Priory of St Bartholomew at Smithfield in London; the manuscript was written in Italy and illuminated in England around 1330–40.

Evidence and realism

When considering the illustrations in a manuscript as historical evidence, it is important to assess the information against knowledge gained from other sources. For instance, a miniature may not directly reflect the customs and manners of the place and time in which the manuscript was written. In some cases, the illustrations were derived from an example made in an earlier century, or in a distant place where different conditions prevailed. For example, in the earliest English occupational calendars, executed in the early 11th century, ploughing is shown as a January labour, instead of a task for spring or autumn (*see* Fig. 4): this is because these English illustrations were probably derived from southern European models, and in southern Europe it is possible to break the ground earlier in the year than in the north. Further, the frequency with which a craft or trade appears in manuscript illumination, where subject matter was largely governed by text and convention, is not always a guide to the importance of a particular occupation. Beer brewing, for example, was a common activity in northern Europe, where beer was the staple drink of the people, but illustrations are rare. Winemaking, however, occurs frequently, since a conventional calendar illustration for autumn

is treading the grape. Also, the manufacture of wine must have been closer to the interests of the wealthy individuals who commissioned and purchased illuminated manuscripts.

Convention and the tastes of a wealthy patron are reflected in the unnaturally neat, tidy and colourful appearance of many illustrations of manual labour. The artist's aim was to produce a work of beauty and the scenes he represented were ideal ones. Indeed, even if the painter had wished to make his work realistic, it is unlikely that the patron would have been pleased if the miniatures in his fine, new manuscript had shown dirty, ragged peasants and craftsmen in rough, dull-coloured clothing. In some illustrations the workers are most unsuitably clad. The man guiding the harrow in PLATE I wears only light shoes, pale blue hose, a smart, short doublet and a full-sleeved dark blue shirt. His companion, the sower, wears less elaborate clothing, but it is coloured red and blue, instead of the brown or grey which would have been normal, and – most impractical for someone working in a muddy field – he wears white hose and boots. Again, the workers shown in an illustration from a manuscript of *Des profits ruraux des champs* (PLATE II), brightly dressed in short doublets and hose of red, green and blue, do not look like farm workers. The man working on the fence wears a gold-studded belt, to which is attached a smart black purse decorated with gold. It would, indeed, be wrong to assume that this was the type of clothing normally worn by 15th-century peasants.

The technical realism with which craft work is depicted varies enormously. Generally speaking, more detail is found in late medieval manuscripts than in those from earlier periods. For example, an early ploughing illustration (*see* Fig. 4), can be contrasted with the treatment of the same subject in the 14th-century Holkham Bible Picture Book (*see* Fig. 3), where almost every detail of Cain's plough can be seen. Further, the carpenters' tools shown in the miniature of building the Ark from the Bedford Hours (PLATE VI) and in a representation of St Joseph's workshop from a Spanish Book of Hours (*see* Fig. 43), would easily be recognized by a modern carpenter. However, on occasions, a technical error will betray the artist's lack of knowledge, interest or care: the examples in this book from a

manuscript of Boccaccio's *Le livre des cleres et nobles femmes* show an armourer's hammer wielded back to front, a weaving loom with no visible mechanical details, and an artist's table suspended in mid-air (Figs 35, 45 and 61).

Someone looking at medieval manuscript illumination for the first time might be struck by the lack of perspective, particularly in examples from before the 15th century, and by the large size of figures in relation to buildings. Also structures and people are sometimes related in a way that can best be described as flimsy. All these features are illustrated by a picture showing the building of the Tower of Babel, from a manuscript made in the early 11th century at St Augustine's, Canterbury (PLATE v). The text, which is illustrated with over 400 drawings, is Aelfric's *Pentateuch*, an Anglo-Saxon version of the first five books of the Bible, with the Book of Joshua. Some of the lively figures in this picture are precariously placed: the man (top left) hauling up a hod of mortar, holds dangerously on to the roof with his left hand while his feet dangle in mid-air. Neither of the men nailing the iron work on the door has his feet on the ground, while the hod bearer to the right looks about to fall off his ladder. The Latin captions to this picture were added in the 12th century.

This book is divided into four sections: agriculture and husbandry; trade and commerce; industry and crafts, and the professions. It was difficult to assign certain activities to a particular section. A scribe or artist would have been considered a craftsman, but the work of book production seems logically to belong with scholarship. A monk might also be a farmer, a scholar, teacher, scribe, craftsman or artist. Similarly, a picture illustrating one group of activities may contain material relating to another: for example, the clerk in a law court is shown with a scribe's tools on his desk. Almost all the illustrations are taken from British Library manuscripts. Medical miniatures are represented by only a few examples, as this subject has already been extensively treated by my former colleague, Peter M. Jones (in *Medieval Medical Miniatures* London, 1984). It was also decided to omit the soldier's art completely, as this could form the subject of a separate book.

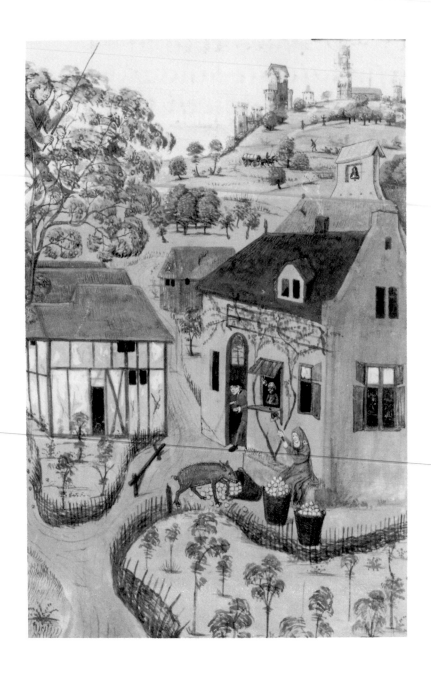

The apple harvest.
Detail from Fig. 11.

Chapter 1

Agriculture and husbandry

Since men ceased to be nomadic hunters, the human race has chiefly depended upon the practice of agriculture for food provision, and in medieval Europe the majority of the population was engaged in working the land. Food that was extra to the needs of the rural community supplied the small number of townsfolk and professional people. The peasant farmer, if his holding was large enough, produced food for his own family, with a surplus for sale to cover the cost of rent, taxes and items he needed to purchase. If he were not a free man, he was also obliged to work on his lord's land as a condition of feudal tenure, although in England this labour service gradually came to be replaced by a money payment. Men who were landless or whose holdings were very small could only earn a living by working for the more prosperous.

Arable farming

The routine of village life centred on cultivation of the fields on a two or three year rotation system, with one field at a time lying fallow. One field was ploughed and sown in spring with corn, peas or beans, and the previous year's fallow field was ploughed three times before winter corn was sown in autumn. Walter of Henley, who wrote a treatise on husbandry at the end of the 13th century, gives instructions for ploughing the last year's fallow: the ploughman is to break up the land well in April, to plough lightly at midsummer 'so that you may destroy the thystels and the grasse utterlye', and at sowing time in the autumn to plough 'two fingers breadth deeper' in furrows 'well ioyned together that the seede may falle even'. Ploughing in bad weather was a miserable task: the poor ploughman described in the 14th-century poem *Pierce the Ploughmans Crede* struggled in mire up to his ankles, his wife walking beside him barefoot on the icy ground, urging the animals on 'with a long gode'. The ploughman needed considerable skill in handling and adjusting his plough to cut ridges of the correct depth and width. Three types of plough were used, with or without a mould-board; the swing plough, the foot plough and the wheeled plough.

The basic design of the medieval plough was unchanged since prehistoric times; the parts are shown in the illustration of a swing plough in the Holkham Bible Picture Book (Fig. 3). The draught animals are harnessed to one end of a long beam, the other end of which is attached to the stilt or handle. Fixed in the beam behind the animals is the curved coulter, which broke the earth, while the horizontal ploughshare, at right angles to the stilt, made the furrow. Both the coulter and ploughshare are shod with iron. A mallet, used to adjust the movable joints of the plough, is fixed to the stilt, while the ploughman holds a rake in his right hand, ready to clear mud from the implement.

A man using a swing plough, which was most useful on heavy soil or uneven ground, relied on his own technique to regulate the depth of the furrow. However, the foot plough and the wheeled plough were adjustable. A 'foot' of iron or wood, the end resting on the ground, or a pair of wheels, were attached to the beam in front of the coulter; these features could be raised or lowered in relation to the body of the plough to govern the depth of the furrow. Faster than the swing plough, the wheeled plough was best suited to light, well-drained soils, as the wheels became clogged in heavy conditions. The earliest manuscript illustrations of the wheeled plough are of the 11th century: considerable artist's licence is taken in Fig. 4, a calendar illustration for January taken from an English manuscript, showing a wheeled plough with a divided stilt or handle. The wheels barely rest on the ground and there is little

Fig. 3 Cain ploughing. Holkham Bible Picture Book. England; about 1320–30.
Additional MS 47682, f. 6

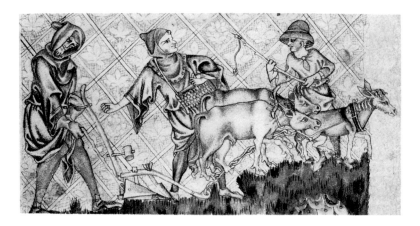

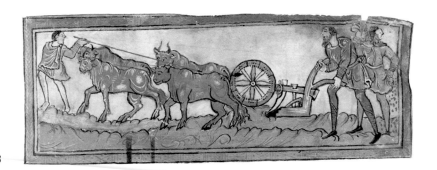

Fig. 4 Ploughing.
January calendar entry.
England; second quarter
of the 11th century.
Cotton MS Tiberius B V, f. 3

sign of harness attaching the oxen to the plough. Fig. 5, an illustration for March from the calendar of a late 15th-century Flemish Book of Hours, shows a wheeled plough with a single frame. The heavier implement in the background of PLATE I, a leaf bearing the September calendar illustration from a Book of Hours made in Bruges about 1520, has a double or four-sided frame. This manuscript is known as the Golf Book, since the surviving pages bear a series of illustrations of sports and pastimes, including the game of golf.

Fig. 5 Ploughing.
Book of Hours. Probably
Bruges; late 15th century.
Additional MS 17012, f. 3

The mould-board plough represented a technological

improvement: the ploughshare did no more than scratch a fur-
row in the earth, but if a curved board, the mould-board, was
fixed to the side of the plough foot, the furrow was turned as
it was cut. The earliest illustration of a mould-board plough
occurs in the Luttrell Psalter (Fig. 6): the mould-board made
the plough heavier, and the Luttrell ploughman no doubt
needed two stilts to steer the implement.

The plough was usually pulled by oxen, horses, or a
combination of both, harnessed abreast or in single file. Oxen
were slow and strong, best suited to heavy haulage and soil
conditions, while the horse was quicker and useful on stony
ground where the oxen's feet might slip. The horse was also
used for lighter farm work, for example harrowing, pulling
carts or as a packhorse. Walter of Henley estimated that the ox
was more economical to keep, particularly since 'when the
horse is olde then hathe he nothing but his skynne . . . But
when the oxe is olde with xd [10*d*. worth] of grasse he wilbe
made fatte to kylle or to sell for as muche as he coste youe'.
However, the horse's speed and versatility outweighed the
expense, and the number of horses in proportion to oxen used
in farm work increased throughout the middle ages. The
ploughing scene in the Luttrell Psalter (Fig. 6) shows four
oxen yoked abreast in pairs, their yokes attached to the plough
beam by a rope: the yoke was suitable for oxen because of their
wide shoulders. Two yoked oxen and an ass with a padded

Fig. 6 Ploughing.
Luttrell Psalter. England;
before 1340.
Additional MS 42130, f. 170

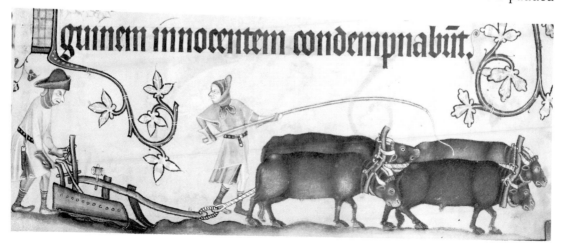

collar, all attached to the beam by a chain, pull the plough in the illustration from the Holkham Bible Picture Book (*see* Fig. 3). A harnessing device that allowed greater flexibility of movement was the whipple tree, a horizontal bar attached by traces to the horse's collar and then to the plough (*see* Fig. 5). PLATE I shows the arrangement for harnessing two horses abreast, each with a whipple tree. This illustration also shows reins, passed through bits in the horses' mouths and controlled by the drivers: the plough reins are passed back across a superstructure.

After ploughing, the seed was sown, scattered by hand from a basket around the sower's waist, or simply from an apron. Then a harrow was drawn across the field to cover the seed (PLATE I): the harrow was a simple wooden frame, usually rectangular, with teeth on the underside. During the summer the fields needed weeding, but the busiest time of year was harvest time. Barley, oats, rye and pulses were mown with scythes; wheat ears were cut high up on the stem with a sickle and bound in short stemmed sheaves which dried quickly. The remaining stalks were cropped for straw for winter bedding. The unfortunate peasant, however, was bound by feudal obligation to help reap his lord's harvest, just when he needed

Fig. 7 Reaping. Queen Mary Psalter. England; early 14th century. *Royal MS 2 B VII, f. 78 verso*

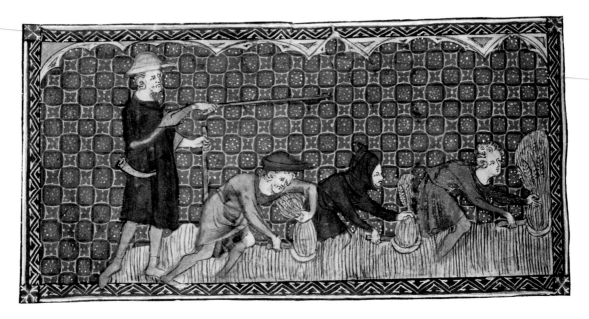

to gather his own crops on which his family's livelihood depended. At times coercion was necessary: for example, a tenant of the Abbot of Pershore was accused at the manor court of Hawkesbury in Gloucestershire in 1290 of not sending his children to labour in the lord's harvest. The August calendar scene from the Queen Mary Psalter, an English manuscript of the early 14th century (Fig. 7), shows peasants reaping under the direction of an overseer, who wields a stick. However, the reaper depicted in the July calendar illustration from a Book of Hours illuminated in Paris in the mid 15th century (Fig. 8) looks happier, maybe thinking of his lunch bag and bottle waiting in the shade of the stooks.

After the harvest was gathered and fetched home, the corn

Fig. 8 Reaper. Book of Hours. Paris; mid 15th century. *Egerton MS 2019, f. 7*

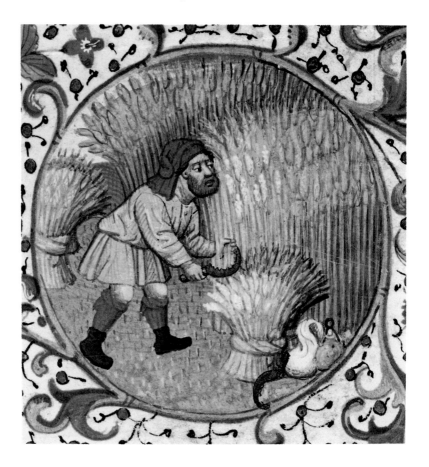

Fig. 9 Threshing and winnowing.
Book of Hours. Probably Bruges; late 15th century.
Additional MS 17012, f. 12

was threshed with a flail. The flail was made of two pieces of wood joined by a leather thong, and the thresher brought one end of the implement sharply down onto the ears of corn to separate the grain from the ears. The threshing scene in Fig. 9, the December calendar scene from a late 15th-century Flemish Book of Hours, takes place in an outhouse: the figure by the door is winnowing, shaking the corn in a basket so that the chaff blows away in the draught.

Horticulture and general tasks

Besides farming the arable, there were many other jobs to be done in the spring and summer months, and manuscripts of *Des profits ruraux des champs* by Petrus de Crescentiis are a source of illustrations of this work. Hay was cut with scythes from the meadows in June, to provide winter fodder for animals: Fig. 10 is taken from a manuscript produced in Bruges in the late 15th century. Fences and buildings needed repair after the winter: PLATE II, from a late 15th-century manuscript

Fig. 10 Haymaking.
Petrus de Crescentiis, *Des profits ruraux des champs*.
Bruges; late 15th century.
Royal MS 14 E VI, f. 204

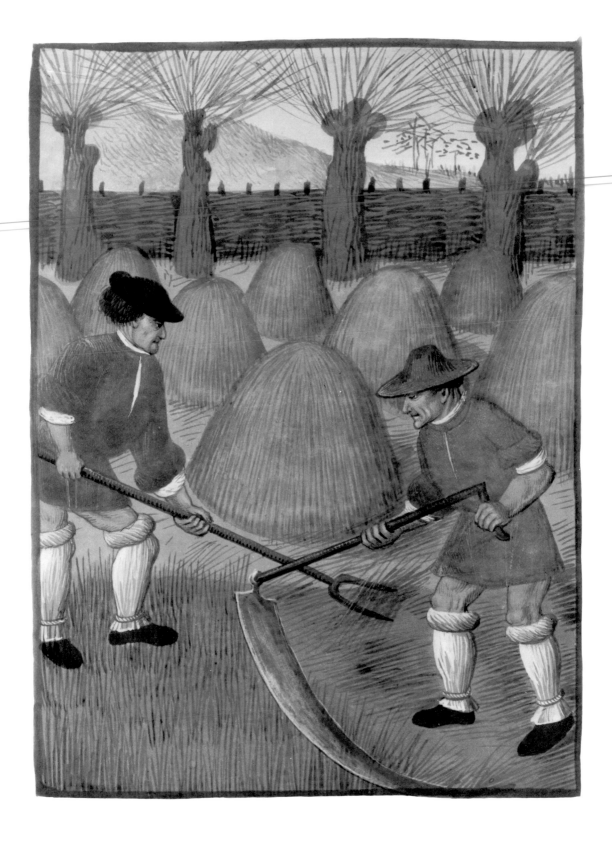

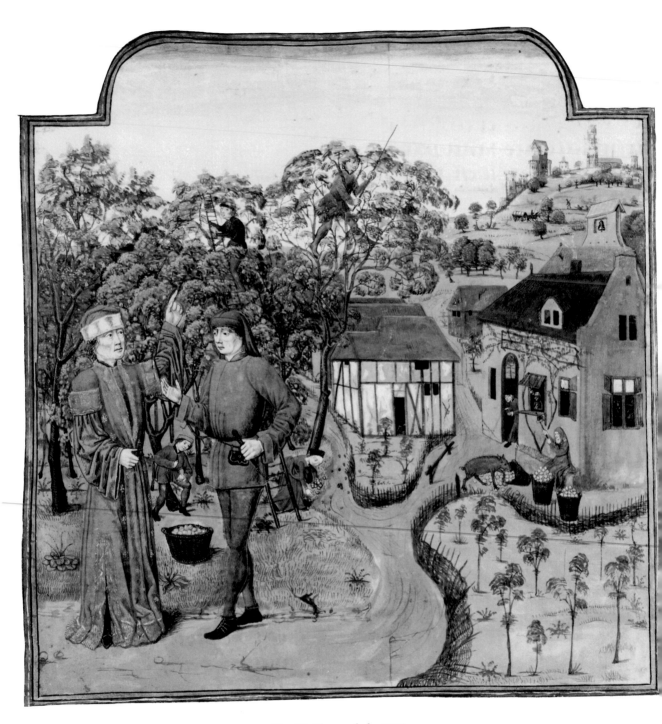

Fig. 11 The apple harvest.
Petrus de Crescentiis, *Des profits ruraux des champs*.
France; late 15th century.
Additional MS 19720, f. 117 verso

Fig. 13 *(Overleaf)* Pruning and staking vines. Book of Hours. Possibly Ghent; late 15th century. *Egerton MS 1147, f. 7 verso*

executed in France, shows a wattle fence under construction. One man is stripping the wattles with a knife while another weaves the prepared strips around the uprights. A heavy mallet, used for hammering in the uprights, lies on the ground. To the right of the picture a third man is felling a tree that has been stripped of its branches, while a fourth is digging with a long-handled spade, preparing to plant trees in replacement for those felled. The figure in the long red gown standing beside the straw stack represents the author.

Work also had to be done in the garden and orchard. Most peasants had a small plot in which they grew vegetables and herbs. Piers the Plowman, in William Langland's poem, eked out his diet of cheese, oat cakes, bread and beans with parsley, onions and plenty of greens. Records of royal, noble, ecclesiastical and monastic establishments provide a great deal of our information about medieval gardens: gardeners in these households grew a wide variety of fruit, vegetables and herbs for home consumption and for sale. The garden was frequently enclosed by a fence, hedge or wall, a feature that can still be seen in country house gardens today. In another illustration to Crescentiis (*see* Fig. 42), a workman is fencing a square garden plot at a country house. A miniature from the same manuscript, depicting the apple harvest (Fig. 11), shows nursery plots of young trees, while in Fig. 12, a March calendar entry from a late 15th-century Flemish Book of Hours, gardeners are at work in a herb garden with raised beds.

Fig. 12 The herb garden. Book of Hours. Bruges; late 15th century. *Additional MS 18852 f. 3 verso (detail)*

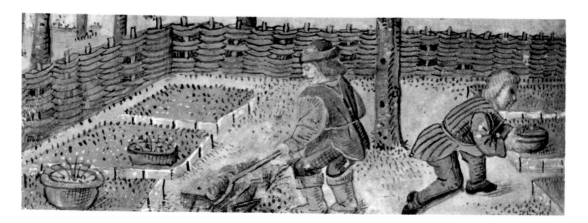

Fig. 14 Planting vines and harvesting grapes. Petrus de Crescentiis, *Des profits ruraux des champs*. France; late 15th century. *Additional MS 19720, f. 80*

In the spring, trees and vines needed to be pruned, an activity frequently shown in calendar illustrations for February or March. The February entry in a Flemish Book of Hours of the late 15th century (Fig. 13) shows a worker pruning and staking vines, while his assistant brings up a load of stakes. Although vine cultivation was more common in England in the middle

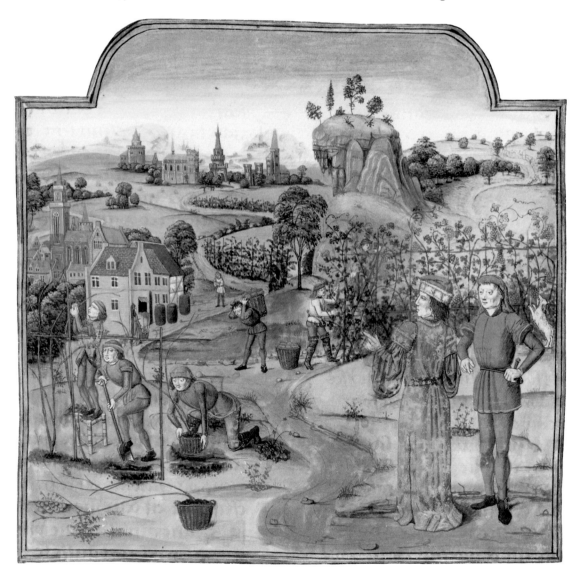

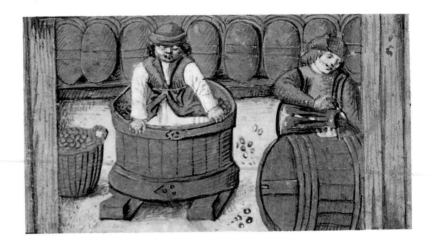

Fig. 15 Making wine.
Book of Hours. Bruges;
late 15th century.
Additional MS 18852, f. 10
(detail)

ages than it is now, it was, of course, much more important in continental Europe. Fig. 14, illustrating the chapter on the vine in the Crescentiis treatise, shows men planting out vines: the plants have been brought to the site in wicker baskets of earth. Three men are involved in this operation – one digging, one planting and a third tying the vines to the frame of uprights and horizontals on which they are to grow. On the other side of the road it is already harvest time; picking is in progress and large baskets of grapes are being carried down to the house for winemaking. The dog appears to be carrying out a private harvesting operation of his own. Winemaking is the usual subject for September calendar illustrations in Books of Hours: in Fig. 15, the September miniature from a late 15th-century Flemish manuscript, one man is treading the grapes to extract the juice, while another fills a barrel from a pitcher, to begin the fermentation process.

Livestock

PLATE I The harrow.
Golf Book. Bruges; about
1520.
Additional MS 24098, f. 26
verso

Mixed farming was universal in the middle ages and most holdings except perhaps the very poorest would have supported livestock. Most written evidence of animal husbandry relates to large estates. Teams of oxen were maintained on the lord's home farm or demesne, but poor men would have

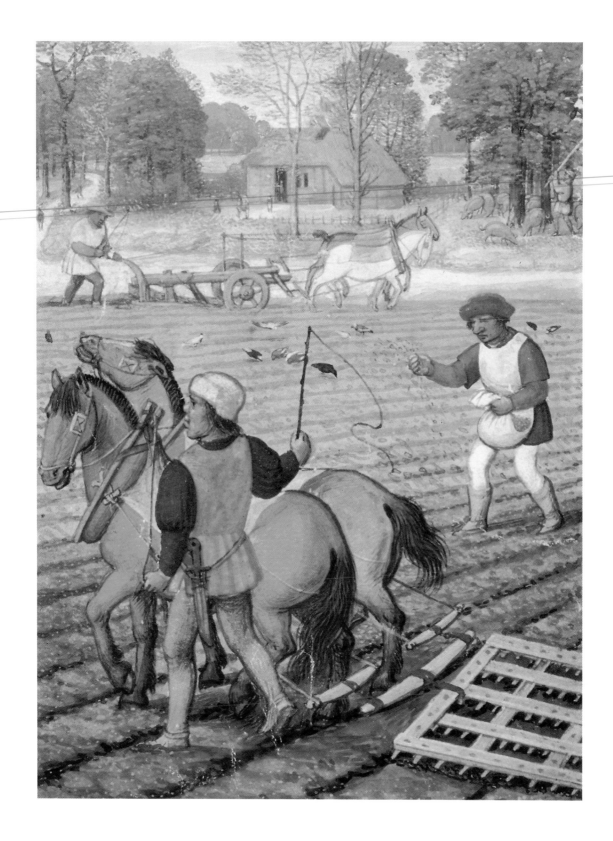

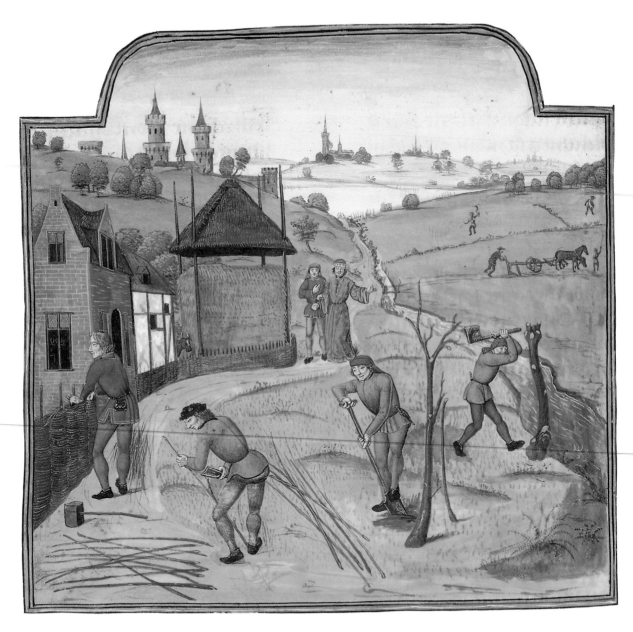

PLATE II Fencing.
Petrus de Crescentiis, *Des profits ruraux des champs*. France; late 15th century.
Additional MS 19720, f 288 verso

needed to borrow animals at ploughing time. Cows, which could be used as draught animals when not in calf, were more important as breeding animals than for milk. Sheep were kept almost everywhere, providing milk, wool and manure for the land, while goats were more common on the European mainland than in England. On a large holding livestock were kept in outbuildings in the farm yard when not grazing, and sheep were brought into sheep houses in the worst of the winter weather. However, a poor man's house was usually partitioned, half of it providing a stable for his animals.

Fig. 16, the April calendar entry from a late 15th-century Flemish Book of Hours, shows a fenced farm yard with poultry scratching; a small flock of sheep and two goats are being led out to graze from an outhouse, together with two cows, who appear to have come from a thatched building on the other side of the yard. Only a well-off peasant would have owned so many animals: Piers Plowman had no money for hens, no geese and no pigs, only possessing '. . . a cou and a calf and a cart-mare To drawe a-feld my donge . . .'. The poor widow of Chaucer's 'The Nun's Priest's Tale' from *The Canterbury Tales* may have been a little more affluent than Piers Plowman; besides her cock and seven hens she possessed three sows, three cows and a sheep.

Numbers of sheep kept increased throughout the middle ages in England because of the importance of the wool trade. Sheep predominated in some areas, for example Wiltshire and East Anglia, and on large estates full-time herdsmen and

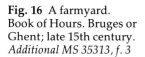

Fig. 16 A farmyard. Book of Hours. Bruges or Ghent; late 15th century. *Additional MS 35313, f. 3*

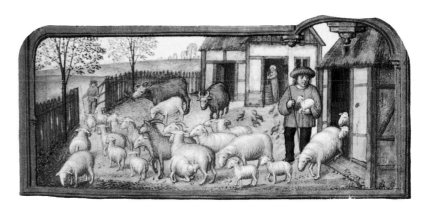

shepherds were employed to care for the animals. The duties of a shepherd are set out by Walter of Henley, and also in another 13th-century treatise on estate management, the *Seneschaucy*: the shepherd has to maintain the sheepfold and sleep there with his dog and the sheep; he must ensure they do not 'pasture in forbidden moors, ditches, and bogs thereby contracting illness and rot through lack of supervision'; and he must not go to fairs, markets, wrestling matches, taverns or to visit friends without asking permission and finding a suitable substitute. Flocks were inspected regularly for disease; liver fluke was an infectious killer and sick sheep had to be put down; animals infected with scab, which ruined the fleece, together with the old and infirm, were fattened for meat.

Full-time shepherds were assisted by tenants performing labour service. On the estates of the Templars in Wiltshire, every tenant holding five acres of land had to send a woman each day to milk the ewes, and to wash and clip the sheep at shearing time. The sheep were washed before shearing to ensure a clean fleece. Fig. 17 shows a woman milking ewes in a fold, while a man is treating a sheep, perhaps with ointment for

Fig. 17 The sheepfold.
Luttrell Psalter. England;
before 1340.
*Additional MS 42130, f. 163
verso*

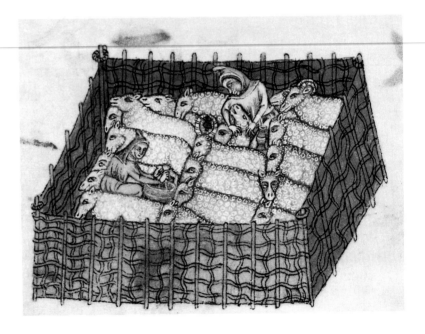

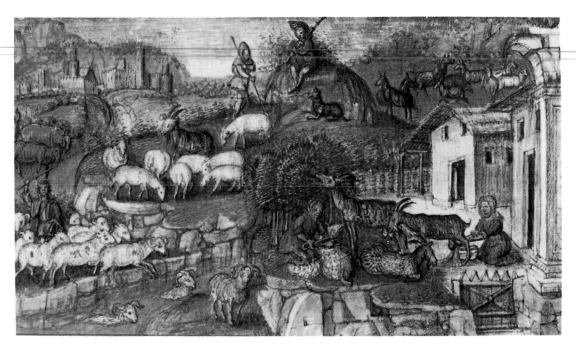

Fig. 18 Shepherds.
Virgil, *Georgics*. Italy; late
15th century.
King's MS 24, f. 37

scab. Various aspects of a shepherd's work are depicted in an illustration to Virgil's *Georgics*, in a late 15th-century Italian manuscript (Fig. 18). At the top of the picture two shepherds are minding a flock of goats and sheep in hilly country. Another shepherd is driving sheep across a stream, while near the homestead a man is shearing sheep and a woman milks a goat.

Sheep and cattle were only slaughtered for meat when they were past other usefulness: the pig, however, was the chief source of meat in the middle ages. Poor people could afford to keep the animal, which was economical to maintain. It was able to root in woodland and rough grazing (PLATE I), and also fed on the waste chaff in the farmyard after threshing; the pig in Fig. 11, however, has decided to improve his diet with the best apples, to the annoyance of his owners. Apart from breeding stock, pigs were slaughtered in autumn, providing cured bacon and ham, and lard for puddings during the winter months, as well as fresh meat. Nothing was wasted; even the blood was mixed with cereal to make black pudding. In Fig. 19, the

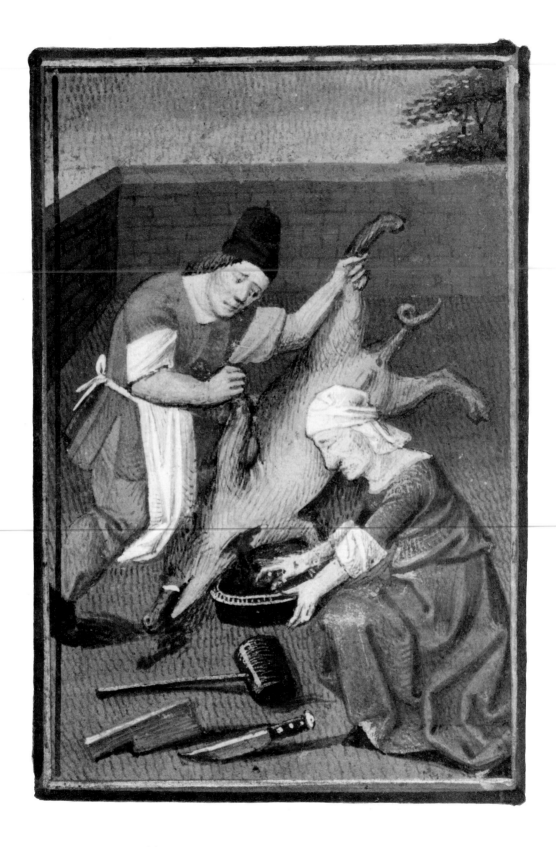

Fig. 19 Killing a pig.
Book of Hours. Paris;
about 1470.
Additional MS 25695, f. 12

December calendar illustration from a late 15th-century French Book of Hours, the woman is catching the pig's blood in a basin; the mallet used to stun the pig and the slaughtering knives are in the foreground.

Apart from their domestic duties, helping in the fields at busy times, shearing and milking, women were traditionally in charge of the dairy and poultry. In the background of Fig. 16, a woman is working in her dairy, using a tall plunge churn to make butter; the action of the plunger disc caused the butter to separate from the butter milk. The *Seneschaucy* describes the duties of a dairymaid on the demesne: she is in charge of the milking, cheese and buttermaking and the stocks of dairy produce; in addition she keeps the geese and hens, has to help with winnowing the corn, and is in charge of keeping and screening the fire, presumably in the kitchen.

The mill

One villager who did not earn his living by cultivating the land and stockrearing was the miller. The ancient method of grinding corn by hand was laborious for large households and the use of wind, water and horsepower saved time. However, the mill was not peculiar to rural areas; for example, watermills were built on the Seine in Paris under the arches of a bridge, which became known as the Millers' Bridge. The Greeks and Romans first developed water mills; these were of two types, the Greek or Norse mill and the Roman mill. The Greek or Norse mill, which was still in use in northern and western Europe in the middle ages, particularly in the Scottish Islands and Scandinavia, was a simple structure with a horizontal wheel placed in a water course; this wheel was attached to a spindle which turned one of the millstones above.

In most parts of Europe, mills were of the Roman or vertical type. The mill was sited by a stream or river; sometimes the stream was dammed to form a mill pond, and the miller controlled the flow of water with sluice gates. The large, vertical, double-framed wheel had paddles between the outer rims to catch the flow of water, and was connected to a smaller

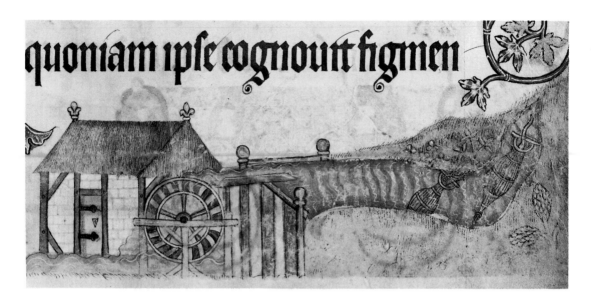

quoniam ipfe cognouit figmen

Fig. 20 Watermill and eel
traps.
Luttrell Psalter. England;
before 1340.
Additional MS 42130, f. 181

wheel within the mill building. This wheel was in turn cogged
to a horizontal wheel, which turned a spindle attached to the
millstones above. This type of mill with a dam is illustrated in
the Luttrell Psalter (Fig. 20). A miniature in a volume of poems
and romances illuminated by a French artist around 1445
shows a mill of three bays, with barrel-shaped water wheels,
set across a river (Fig. 21). The picture is a detail from a
full-page miniature of the city of Babylon, illustrating a
Romance of Alexander the Great.

References to windmills first occur in records in western
Europe in the 12th century; they were possibly a European
invention, or the adaptation of an idea brought from the East.
The type of windmill shown in medieval illustrations is a
tripod post mill. This was a box-like structure containing the
machinery and grindstones, built around a central post; the
lower end of the post was attached to a timber tripod, which
was fixed to the ground. Access to the mill was by a flight of
steps, and a beam on the outside was used to turn the mill
round to face the prevailing wind. The tripod and the beam can
be seen in the illustration of a tripod post mill in Fig. 22, a
marginal illustration to the Smithfield Decretals.

The miller was not a popular figure in the English village.

Fig. 21 Water mill.
Romance of Alexander the
Great. France; about 1445.
*Royal MS 15 E VI, f. 4 verso
(detail)*

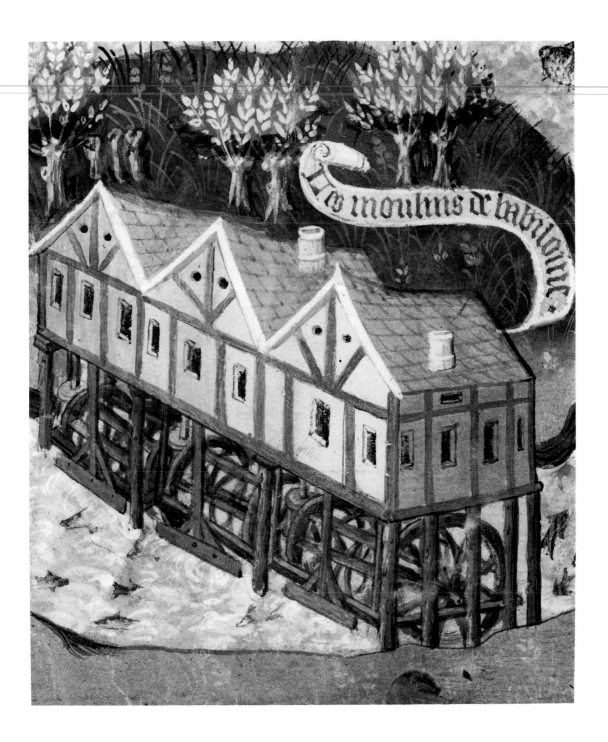

Tenants were obliged to have their corn ground at their lord's mill, where a charge was made, partly to pay for the upkeep of the mill, and some millers levied extortionate sums. Chaucer in the *Canterbury Tales* gives the miller a bad character, 'Wel koude he stelen corn and tollen thries'. Furthermore, the corn had to be taken to the mill, which might be some distance from the peasant's holding. Although a small family could conveniently and cheaply grind their corn on a hand grindstone at home, the peasant risked a fine for this offence in the manor court and seizure of his grindstones. Grievances could have disastrous consequences. The woman illustrated in the Smithfield Decretals bringing her corn for grinding (Fig. 22) was not a satisfied customer; on the following page of the manuscript she is shown setting fire to the mill.

Fig. 22 Windmill. Smithfield Decretals. England; early 14th century. *Royal MS 10 E IV, f. 70 verso*

Chapter 2

Trade and commerce

Towns and merchants

Two conditions are necessary for the development of commerce; first, the desire to exchange goods that are surplus to basic requirements for items that cannot be produced locally, and secondly the town. Commerce, to a medieval villager, meant the sale of spare agricultural produce and the purchase of essential goods such as tools, clothing, leather goods and salt, sometimes from a village craftsman, for example the local blacksmith, but more usually at the nearest small town. A small town needed to be within a day's journey of the villages it served. Some towns, in fact, were little more than large villages; while some of the inhabitants were wholly or partly employed in working the fields outside the town, the majority of the workers were occupied as traders and craftsmen. Textiles, metalwork, carpentry and leatherwork were practised almost everywhere but some towns specialized because of local natural resources: the Cotswolds towns, for example, were centres for the wool trade, while metalworking was important in areas where iron ore was mined and smelted.

Towns developed for a variety of reasons. In the London area, for instance, the small town of Kingston-upon-Thames grew beside the first bridge across the Thames above London, possibly the site of an earlier fording point. A country town, which was the administrative and judicial centre for a large area, might also be the site of a bishop's see, and would certainly contain a number of religious houses. Such a town, with a large non-agricultural population needing to be fed and housed, provided plenty of employment for the victualling and building trades. The city of Norwich is a good example of a town of this type. Lying on a river navigable from the port of Yarmouth, it is at the centre of a web of roads coming in from the surrounding countryside. The main features of medieval Norwich can still be seen: the castle, the cathedral behind the wall of the Close, the numerous churches and the commercial centre, the main market square.

All towns held a market, and this was often the focus around which the town developed. Held once a week in small towns, or more frequently in larger centres, the market was important for the development of trade. Although the inhabitants of medieval towns held their tenements by money rent and were free of

Fig. 23 The market of Porte Ravegnano, Bologna.
Register of the Drapers' Guild of Bologna.
Bologna, Museo Civico Medievale, MS 93, f. 1

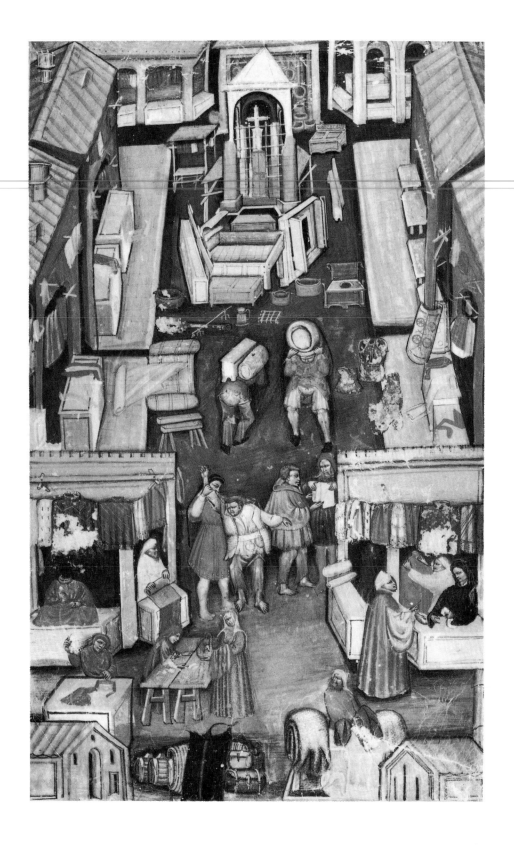

servile obligations, town government and trade were usually controlled by the municipal gild. This was an association of leading burgesses, and only burgesses, often simply the gild members, were allowed to trade and open shops in the town. Furthermore, individual crafts and trades were controlled in the larger towns by their gilds or fraternities. These gilds exercised authority over quality and trading practice, but also restricted admission to their society for fear of competition. At the market, however, traders from outside the town, as well as peasants from the surrounding countryside, could offer goods for sale, and the presence of these traders would in turn offer the town craftsmen a wider market for surplus goods they had produced.

At the market goods might be set out on simple tables (*see* PLATE IX), or on booths in a covered market hall. Fig. 23 shows the market of Porte Ravegnano in Bologna around 1411, at an hour of the morning when trade is just beginning. Some of the booths are permanent roofed structures, with paving outside on which the counters stand, and hanging rails for displaying goods. When unoccupied, or in wet weather, the counters could be pushed back under the roof for protection, as in the booth at the rear of the picture. Porters are busy, and in the foreground a pile of packaged goods, probably a stall-holder's stock, awaits attention. Most of the goods for sale are textiles (not surprisingly, since the illustration is taken from the register of the Drapers' Gild of Bologna). However, one booth at the back displays pots and pans, and a stall in the course of erection in front of the market cross is surrounded by a variety of metal goods, including fire irons and an object that looks like a commode. At some stalls trade is in full swing: one poor-looking man is trying on a jacket while another inspects a warm hood; to the right of the picture a trader is showing a more prosperous customer a fine robe. Two of the stall-holders are working at their goods; one of them, in the left foreground, is sewing a hood.

In large towns, traders in the same commodity tended to live in the same area, giving rise to street names like Bread Street, Cordwainer Street, Fish Street and Goldsmith's Row in London. The medieval shop was often the front ground floor of a

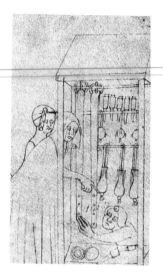

Fig. 24 A booth or stall.
Egerton Genesis. England;
about 1350–75.
*Egerton MS 1894, f. 17
(detail)*

dwelling house, used as both shop and workshop. Opening directly onto the street, the front shutter or 'dressing board' folded down to project into the roadway, for use as a counter in trading hours. Of course, the counter could also be inside the shop: in the perfumer's shop illustrated in a 15th-century English manuscript of John Lydgate's poem *The Pilgrimage of the Life of Man* (PLATE III), mirrors and combs are displayed on the counter, while jars of scent or ointment are stored on the shelves behind. In the miniature, the pilgrim is shown a flattering mirror, and the long-handled objects on the counter are curry combs used on horses, possibly a symbol for the practice of 'currying favour'. Fig. 24 shows a booth or stall selling belts, knives and purses: this drawing, which illustrates the story of Jacob's daughter Dinah, is from a Genesis Picture Book, the Egerton Genesis, executed in England around 1350–1375.

Trade and commerce were the main opportunities open to a medieval man wishing to better himself financially. A small craftsman, by a combination of hard work, enterprise and good luck, might increase his turnover and stock. However, craft work and retail trade were only part of the business of substantial merchants, for men with capital made their fortunes by engaging in wholesale trade. Although a merchant might belong to a specific company, this did not stop him trading wholesale in a variety of commodities: in 14th-century London, for example, fishmongers and vintners, and even prosperous members of artisan craft gilds such as tanners and cordwainers, were involved in the wool trade. The great merchants were also considerable employers of labour: at the height of his career, William Canynges, a leading Bristol merchant of the 15th century, may have employed 800 men on his ships alone.

The Italian towns were leaders in international trade, partly because of their geographical position. The wealth of the ports of Venice and Genoa was founded on trade with the East, particularly in spices and luxury cloth, and with the Christian Mediterranean, while in northern Europe the towns of Flanders, and the Hanse, an association of North German and Baltic towns under the leadership of Lübeck and Hamburg

predominated. During the 12th and 13th centuries, merchants from the north met Italian traders at the great fairs of Champagne.

Similar to a market, but on a larger scale, the fair was held for a specific period from a few days to as long as six weeks, attracting traders from all over the country and abroad. Sometimes the fair specialised in one commodity, for example the Herring Fair at Yarmouth. Not all fairs were successful. Henry III granted a fair to the Abbot of Westminster for 14 days in October 1248 and suspended all other trade in London for the duration, forcing Londoners to attend. According to the chronicler, Matthew Paris, the fair was a disaster: the weather was frightful and as the stalls were only covered with cloth, probably canvas, the merchants were wet and cold, their feet muddy and their goods ruined. In 1251 the King tried again. This time it rained so much that bridges broke down and the roads were hardly usable. Furthermore, the English did not always behave well to foreign guests. After the Boston fair in 1240, English merchants attacked and assaulted the Flemings, stealing their money and ruining their goods. Fairs declined in importance in the later middle ages, partly due to improvements in banking methods, which enabled merchants to stay at home, yet to deal further afield through their agents.

England traded with the whole of Europe: from Flanders came fish, raw materials, linen and a variety of manufactured goods; wine was imported from France; from the Mediterranean came dye stuffs, spices, drugs, luxury cloths and citrus fruits; from the Baltic, fish, naval stores such as tar, hemp and pitch, furs and minerals. England's greatest export, the item on which her wealth was founded, was wool, and later cloth.

Growth of the Flemish cloth industry in the 12th century stimulated wool production in the British Isles, but particularly in England, where the wool was of fine quality. London merchants, Flemish and other foreign traders, came to purchase wool at English fairs and markets, and also dealt directly with producers both large and small. Large wool producers stored their 'clip', the shorn fleeces, in sheds, and could afford to wait for prices to rise. After shearing, the wool was sorted into categories, for example fine and medium quality, lambswool

and broken wool. Continental buyers entered into contracts with large producers, making conditions of storage, cleanliness, quality and packing; for instance, in 1291 merchants from Cahors agreed to buy all the wool of Pipewell Abbey for a period of 12 years. However, at this date the English wool trade was on the verge of decline, and, during the 14th and 15th centuries, manufactured cloth replaced raw wool as England's leading export.

Banking

Fig. 25 Goldsmiths' shop. Treatise on the vices. Northern Italy; late 14th century.
Additional MS 27695, f. 7 verso

Large-scale trading ventures would have been severely hampered without advances in banking and commercial methods, chiefly developed by merchants from the leading Italian cities, which were the largest and most sophisticated in Europe. It was both inconvenient and risky for a trader to carry large sums of money on long journeys: not only was the coin heavy, but

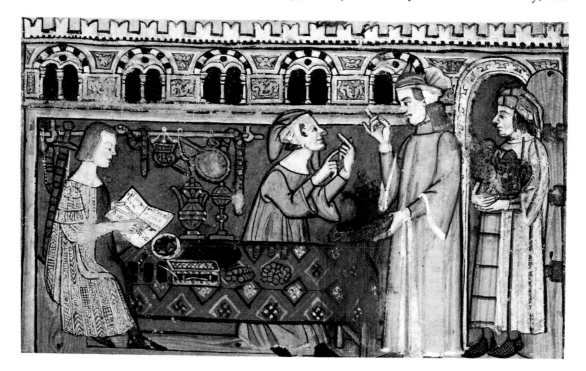

the traveller was in danger from robbers. The problem of carrying cash could be avoided by use of a credit note, by which a merchant promised to repay cash advanced to his agent abroad, or by a bill of exchange. The bill of exchange worked as follows: a London merchant sending an agent to Genoa, for example, would place a sum of money with a Genoese firm in London; the firm would then write a bill of exchange for the English agent to cash in Genoa. Negotiations of bills of exchange led to the development of banking, first of all in Italy, and Italian banks maintained branches abroad. Bankers lent money to finance trading expeditions, as well as to kings, princes and to private individuals, and merchants associated together, or took out 'shares' in a venture, thus minimising the risk to the individual.

Illustrations to a treatise on the vices, composed by a member of a Genoese family and written and illuminated in northern Italy at the end of the 14th century, show the Italian financial community at work. The text at the top of the page shown in PLATE IV refers to the treatment of widows and orphans. In the upper miniature, bankers are depicted counting their money before storing it in a large chest. Four locks are visible on the right-hand side of the chest, making eight in all. Keys to treasure chests with multiple locks of this kind could be distributed among senior members of a firm, so that the chest could not be opened unless several people were present. In the miniature below, two men are making up accounts, while a third deals with a line of customers, headed by women and children. Fig. 25, another miniature from the same manuscript, shows the interior of a goldsmith's shop. Precious metal objects hang from a rack behind the counter, and the female proprietress is striking a bargain while her assistant keeps the accounts. The customers may have brought items for repair or remodelling; however, the pile of cash on the table suggests that she may be purchasing, or even lending money against, the goods.

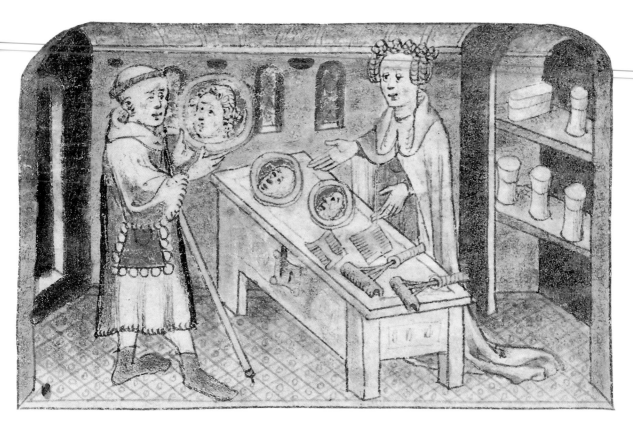

PLATE III Perfumer's shop.
John Lydgate, *Pilgrimage of the Life of Man*. England; mid 15th century.
Cotton MS Tiberius A VII, f. 93

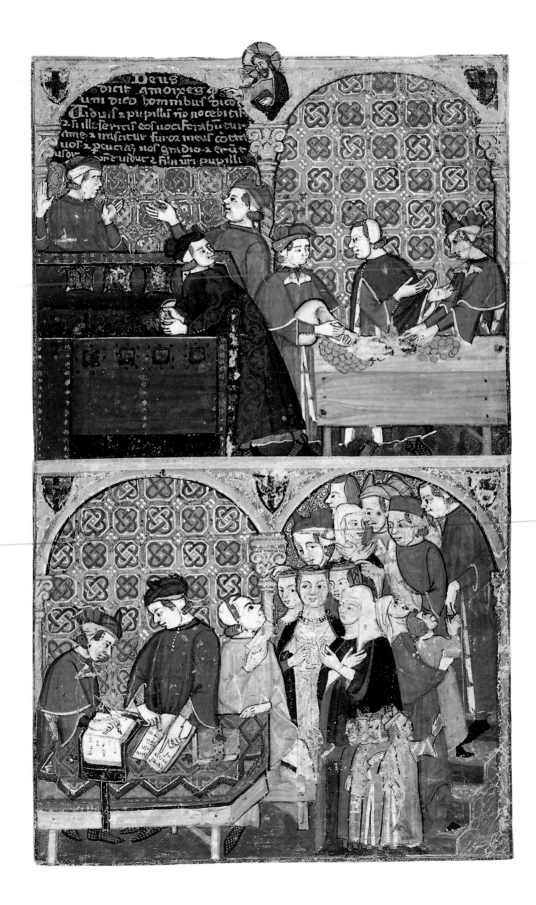

Transport

Safe transport of goods was, of course, an essential factor in any trading venture. By road, goods were carried by packhorse or cart. Packhorses were more reliable in bad road conditions, but it is possible, in view of the large quantities of goods that were transported overland, that the poor condition of medieval roads has been exaggerated. The carter shown in Fig. 26, a detail from a miniature illustrating a treatise on nobility, is driving a four-wheeled cart, loaded with wrapped merchandise; the driver is seated on the horse rather than in the cart, which meant he was less likely to be dislodged in the event of a bump. The manuscript was written at Richmond Palace in 1496, with illuminations in the Flemish style.

Fig. 26 Carter.
Treatise on nobility.
England (Richmond
Palace); 1496.
*Royal MS 19 C VIII, f. 41
(detail)*

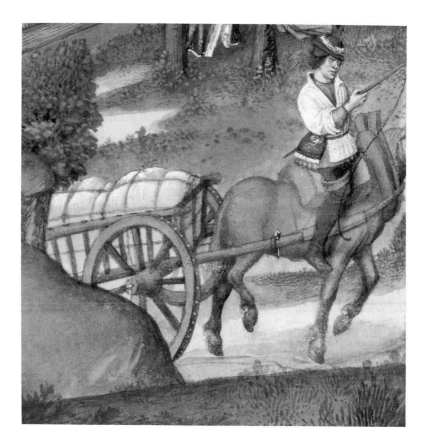

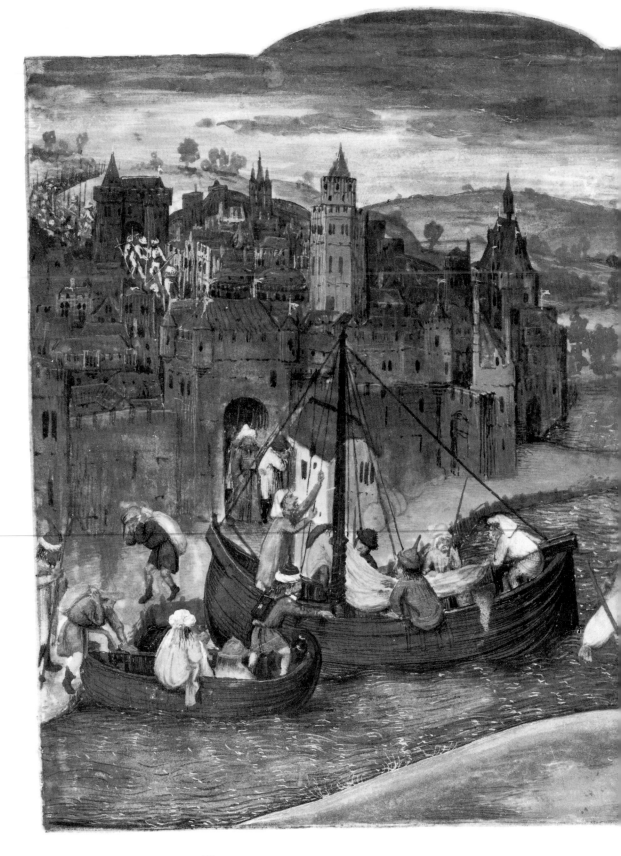

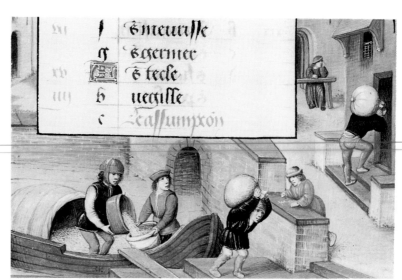

Fig. 27 *(left)* River traffic.
Caesar, *Commentaries on the Gallic
Wars*. France; late 15th century.
Egerton MS 1065, f. 116 verso

Fig. 28 *(above)* Unloading grain from a
barge.
Book of Hours. France; early 16th
century.
Additional MS 15677, f. 8 (detail)

Fig. 29 Beginning a sea voyage.
John Lydgate, *Life of St Edmund*.
England; about 1433.
Harley MS 2278, f. 16 verso

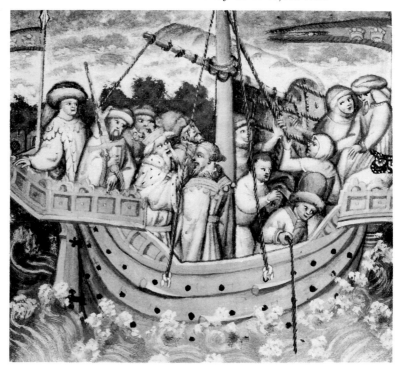

However, it was easier to transport heavy loads by river, and rivers were important trade routes. In Germany, for instance, urban gilds of boatmen controlled river transport. Various types of boat were used according to river conditions – flat-bottomed barges, small open boats or larger boats with a sail. The miniature illustrating the August calendar entry from an early 16th-century French Book of Hours (Fig. 28), shows men filling sacks with loose grain, brought into town by barge. Fig. 27, an illustration to a French translation of Caesar's *Commentaries on the Gallic Wars*, shows the river Rhône at Martigny: sailors are hoisting the sail of a small boat, while passengers board from a dinghy. A similar ship has already set off, pulling a dinghy behind. The manuscript was executed in France in the late 15th century and the miniature represents the flight of the citizens of Martigny before the Roman army.

Sea-going ships were larger, of necessity. Oared galleys were used by the Venetians and Genoese, while by the 13th century the sailing ships used in northern Europe had a single sail and a rudder at the stern. Superstructures – fore and stern castles – developed at either end. A ship with rudimentary fore and stern castles is shown in Fig. 29, a miniature from an English manuscript of John Lydgate's *Life of St Edmund*, written and illuminated around 1433. The subject of the picture is the departure of King Offa of Mercia on a pilgrimage; two sailors are hoisting the sail, while another hauls in the anchor.

The fish trade

Fish was a very important part of the medieval diet, since fresh meat was scarce for part of the year and there were numerous fast days on which meat was forbidden. Although fish were imported to England from the Low Countries and the Baltic, the native catch was an essential natural resource. The East Coast towns were centres for deep sea fishing, and Yarmouth relied almost exclusively on the herring trade. Fish were caught by free moving nets used from a boat, or by standing nets or traps set on the seashore or in a river. Fig. 30, a miniature from a late 13th-century French Gospel Lectionary, illustrates the most

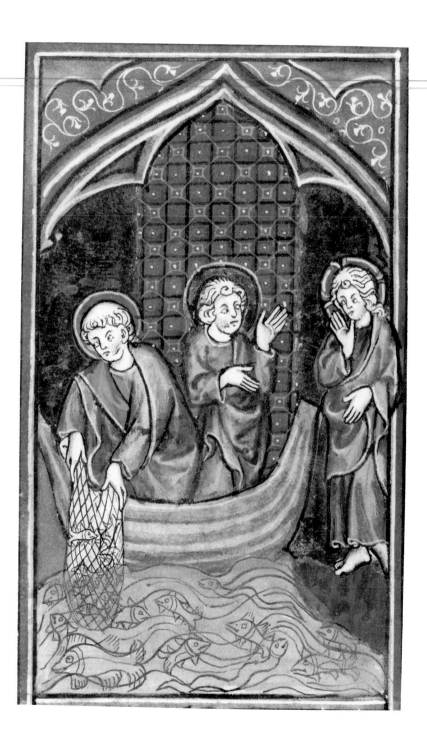

Fig. 30 Fishing: the call of St Peter.
Gospel Lectionary. Paris; late 13th century.
Additional MS 17341, f. 153 verso

famous fishing story of all time – the call of St Peter. Records show numerous fisheries in the rivers, where salmon and eels were caught. Eel traps or kiddles, wicker baskets set in a stream, are depicted in the Luttrell Psalter (*see* Fig. 20); the fisherman here has been lucky, for an eel's tail protrudes from each trap.

Storage was a problem before refrigeration and fish were dried in the open air, smoked or salted for preservation. However, the angler illustrated in Fig. 31, the February calendar miniature from an early 15th-century French Book of Hours, may be anticipating fresh fish for supper.

Fig. 31 The angler. Book of Hours. France; early 15th century. *Additional MS 29433, f. 2*

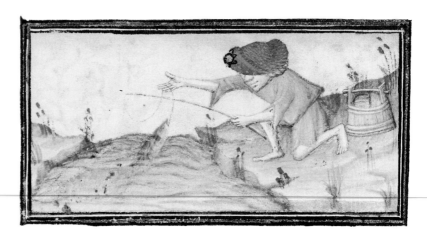

Chapter 3

Industry and crafts

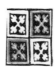

There are two types of industry, the primary process of extracting raw materials and the manufacturing process. The former, of course, has to be carried out where the raw material is to be found, while the second can take place adjacent to the site of the extracting operation, in a nearby town, or even further afield. Some industries, therefore, developed in rural areas, near to sources of raw materials, while others were town based: the mining industries of East and Central Europe contributed to the development of metalworking in the towns of South Germany. In England, metal trades predominated in towns such as Gloucester and Worcester, which were near to the iron mining area of the Forest of Dean, while the English cloth industry developed partly in country wool-producing areas and partly in town.

Mining and metalwork

The main extractive industries were mining for coal, iron, lead, tin and copper, and quarrying for stone, slate, marble and chalk. Coal, which was chiefly used for industrial purposes, for example by metalworkers and lime burners, was washed ashore by the tide in some areas. The coal was simply picked up on the beach and was called sea-coal, a term that was also used for coal transported by sea. The simplest mining operations were opencast working and quarrying of outcrop. Fig. 32 shows men quarrying for minerals, illustrating the section on minerals in Bartholomaeus Anglicus, *Des proprietez des choses*.

A seam running near the surface could be exploited by digging a horizontal trench, but when mines were dug, these were usually of the bell-mine type. A shallow pit was sunk, hollowed out at the bottom as far as was safe and reinforced with pit props: when mining was no longer safe the pit was abandoned and another dug nearby. The coal or ore was carried to the surface in baskets. At the end of the middle ages deeper pits were dug, drained by horizontal shafts.

Before metal could be used in manufacturing processes, the ore had to be smelted and this was done at the mining site. Iron ore was first washed on a coarse sieve and then burnt in a kiln

Fig. 32 Quarrying.
Bartholomaeus Anglicus,
Des proprietez des choses.
Bruges; 1482.
Royal MS 15 E III, f. 102

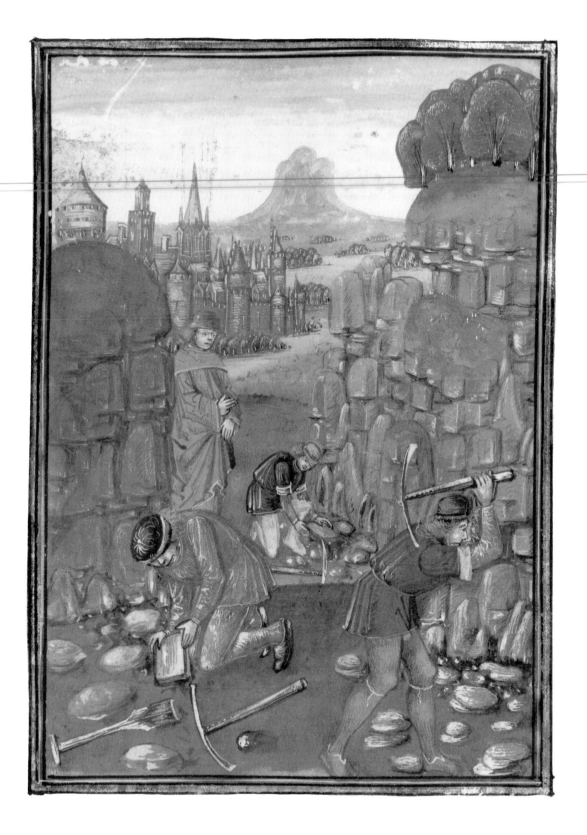

with charcoal; this preliminary burning rendered the ore breakable. The ore was then broken up and taken to the furnace, a structure built around a bowl-shaped sandstone hearth. Layers of ore and charcoal were piled in the furnace and in the process of burning the iron settled into the bottom of the bowl. A forge, where the iron was worked by smiths into blocks with a sledge-hammer, was usually attached to the smelting house.

The work of smiths was varied. They forged iron into rods of a quality suitable for making more elaborate objects, repaired and produced tools and implements, and also shoed horses. In Fig. 33, blacksmiths in aprons are beating a lump of hot iron on an anvil. Their forge has a chimney, with two large pairs of bellows, used to fan the flames, hanging behind. A heap of coal, the fuel used by smiths, is stored behind the forge, and beside the fire hangs a pair of tongs, used for grasping the hot metal. This illustration is taken from a mid 14th-century Flemish manuscript of an astronomical treatise on the Signs of the Zodiac. Nails were an important iron product, used everywhere in building work. Fig. 34, a November calendar illustration from an 11th-century English manuscript, shows a

Fig. 33 Blacksmiths. Treatise on the signs of the Zodiac. Southern Netherlands; mid 14th century.
Sloane MS 3983, f. 5

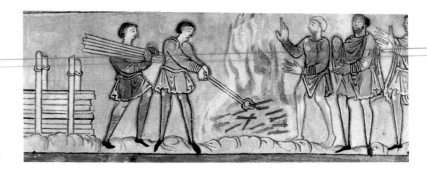

Fig. 34 Making nails. November calendar entry. England; second quarter of the 11th century. *Cotton MS Tiberius B V, f. 8*

smith heating nails on an open fire, a preliminary to beating them into shape.

Metalworkers were not always popular in towns due to the noise they made and the danger of fire; in 1394 the City of London authorities forbade blacksmiths to work at night, that is after 9 p.m., and after 8 p.m. in mid-winter. A London armourer was the subject of a complaint by Assize of Nuisance in 1378: his neighbours alleged that he had built a forge, made of wood instead of the stone and plaster required by City regulations as precaution against fire, adjacent to their house. The chimney of the forge was 12 feet too low. The armourer's sledge-hammers disturbed the plaintiffs by day and night, shook their walls and ruined the beer and wine in their cellar, while their house was foul with the smell of smoke from the sea-coal used in the forge. Unfortunately, the result of the case is not recorded.

The neat, well-dressed armourers working under the instruction of the goddess Minerva (Fig. 35) do not look as if they could ever give cause for complaint. One man is shaping a helmet on a stand; he holds his work with pincers because the metal is hot. Unfortunately, the artist has painted him wielding his hammer the wrong way round, striking the helmet with the pointed toe of the hammer head. Detailed work was done when the metal was cold: the seated man is rivetting the rings of chain mail together with pincers, while the worker standing at the bench is attaching circles of metal to a backing of leather or linen, to make some kind of defensive garment. The miniature is taken from an early 15th-century French manuscript of Boccaccio's *Le livre des cleres et nobles femmes*.

Among the metalworkers, gold and silversmiths were highly skilled craftsmen in a luxury trade, and some of their work was of high artistic value. Besides producing plate and jewellery for the well to do, goldsmiths also engraved seals, while gold-beaters produced the fine gold leaf used in manuscript illumination and for other artistic gilding work. In England, the

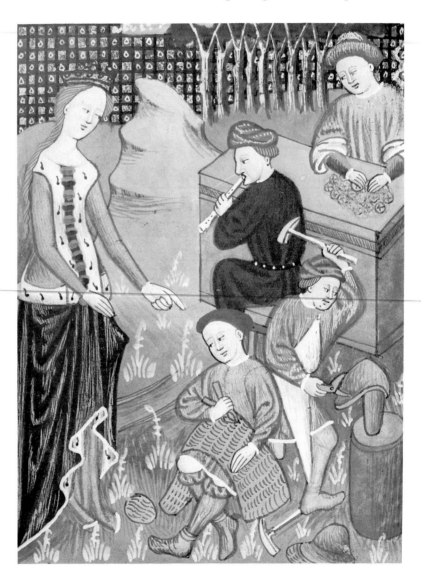

Fig. 35 Armourers. Boccaccio, *Le livre des cleres et nobles femmes*. France; early 15th century. *Royal MS 16 G V, f. 11*

Court was an important patron: at Christmas and New Year 1481–82, John Shaa, a London goldsmith, produced goods worth nearly £800 for Edward IV, including flagons, bowls, cups and a salt costing nearly £400. Shaa was also employed as engraver and master-worker in the royal mint at the Tower. London goldsmiths were closely involved with the Crown's monetary policy and members of the craft frequently acted as senior officers of the mint, and also of the exchange, where broken plate and foreign coin were bought and sold. To protect the coinage, English gold and silver goods had to be made of metal of a certain standard. Regulations were enforced by the Goldsmiths' Company, and wardens of the craft had to

Fig. 36 Goldsmiths. Old Testament Picture Book. Northern Italy, probably Padua; about 1400.
Additional MS 15277, f. 15 verso

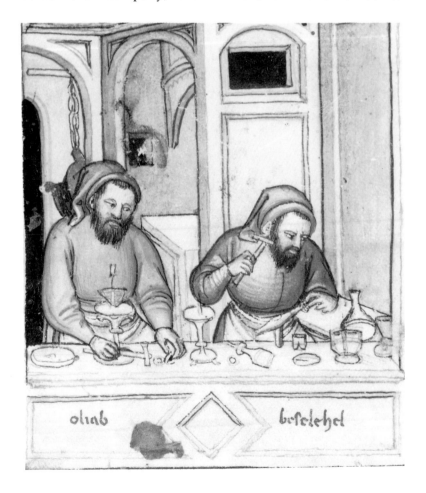

examine all finished objects, stamping silverware with the leopard's head as a sign of approval, while all trading in precious metal goods was supposed to take place in public. Restrictions were avoided, however, by traders who set up shop in dark alleyways, secretly buying poor quality metal from foreign merchants to melt down, and making counterfeit articles. A charter of Edward III to the Goldsmiths' Company, dated 1327, forbade any goldsmith to set up in business except in Cheapside, the goldsmiths' quarter, where their activities could be supervised by the Company.

Like other metalworkers, gold and silversmiths needed to use a furnace and melting hearth. Fig. 36 shows two goldsmiths in their workshop: one man is using a miniature anvil, and the furnace is just visible in the background by the door. The illustration is taken from an Old Testament Picture Book written and illuminated in Northern Italy, probably at Padua, around 1400. It represents the story from the Book of Exodus of Bezaleel and Oliab making candlesticks and other liturgical objects for use in the tabernacle.

Building and allied trades

Building was a boom industry by the 13th century: the population was increasing, towns were growing and the wealth created by the expansion of trade produced a surplus for expensive projects. The finest works – like cathedrals, monasteries and churches – were, of course, outnumbered by numerous dwelling house constructions, and there was also constant need for repair work. Furthermore, jerry-building is not a modern phenomenon and the medieval buildings we see today are among those that were properly built. Many buildings did not survive because of structural defects: for example, the tower of Ely cathedral collapsed in 1321 and was replaced by the present lantern.

Building construction involved many groups of workers, of all levels of skill: masons and carpenters; tilers and thatchers; bricklayers and paviours; plasterers, daubers and unskilled labourers; brick and tile makers, and lime burners, who

produced the lime used to make mortar by burning chalk or limestone.

Local labour resources were not sufficient for a large project such as an abbey or cathedral, and workers had to be gathered from other areas. In particular, masons were itinerant workers, because of the relatively small amount of stone building that took place, while carpenters found plenty of employment in their local towns, where most houses were of wooden construction and naturally contained wooden fitments. The mason's 'lodge' originated in the lodgings provided near building sites to accommodate masons and other workers.

A large building operation was controlled by a 'Master of the Works', usually a mason but sometimes a carpenter, who acted as architect for the project. The master, who needed to be capable of drawing up plans and of marking the foundations out on the ground, is shown in Fig. 37 with an enormous pair of compasses. The drawing illustrates a text composed by the chronicler, Matthew Paris, 'The Lives of the Offas'. This manuscript was actually written at St Albans by Matthew Paris

Fig. 37 Building St Albans Abbey.
Matthew Paris, 'The Lives of the Offas'. St Albans; early 14th century.
Cotton MS Nero D I, f. 23 verso

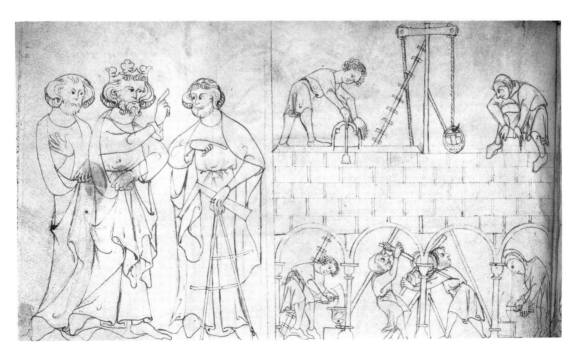

PLATE V Building the
Tower of Babel.
Aelfric's Pentateuch.
England; early 11th
century.
*Cotton MS Claudius B IV,
f. 19*

around 1250, but the drawing was added in the early 14th
century. The picture represents the building of St Albans
Abbey by Offa of Mercia, who is shown consulting with the
master mason. To the right, work is in progress. On the ground
level, two masons are cutting stone, while labourers are haul-
ing material in a basket to the upper storey. Here, one man is
laying stone, while another tests the lie of the wall with a
plumb level.

Before the masons could start work on a stone building,
foundations were dug and filled with rubble. Walls were either
built simply of rough stone set irregularly in mortar, or were
faced with ashlar, squared blocks of stone laid in regular
courses. The inner wall of rough stone was plastered to give a
smooth finish; a thick wall might be faced with ashlar on both
sides, with a core of rubble.

Masons were divided into two groups – the men who cut
the stone and executed fine carving, and the workers who set or
laid the blocks. A miniature from an early 15th-century French

Fig. 38 Building a city.
Romance of Alexander the
Great. France; early 15th
century.
Royal MS 20 B XX, f. 82

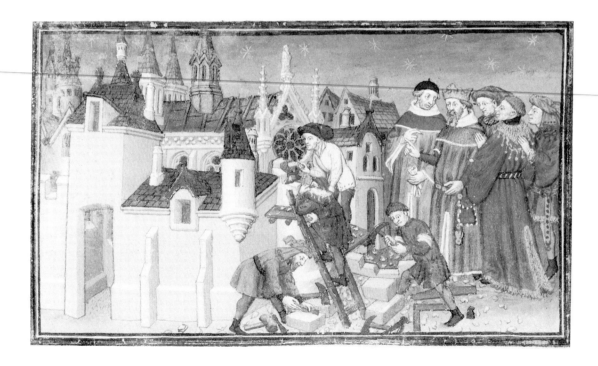

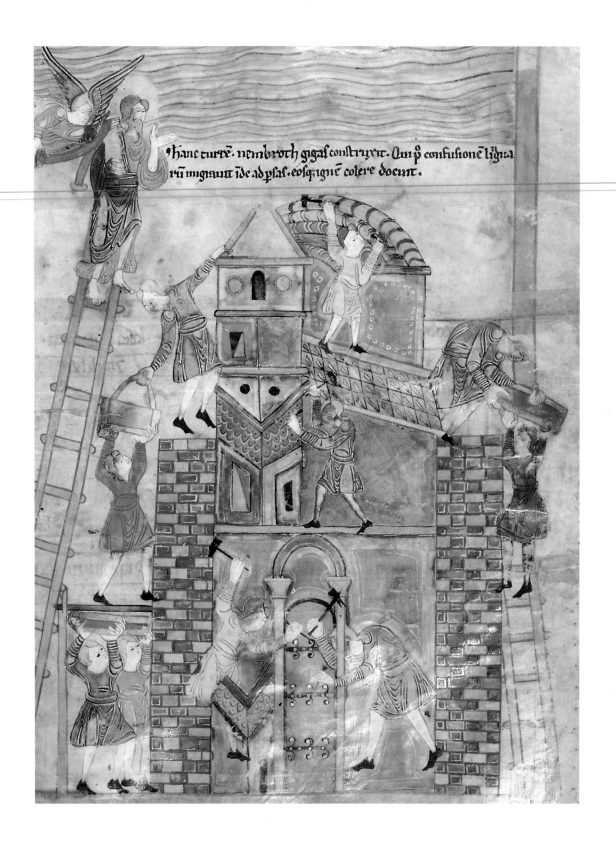

Hanc turrē. nembroth gigas construxit. Qui p̄ confusionē lingua
rū migrauit īde ad psal. eosq̄; igne̅ colere docuit.

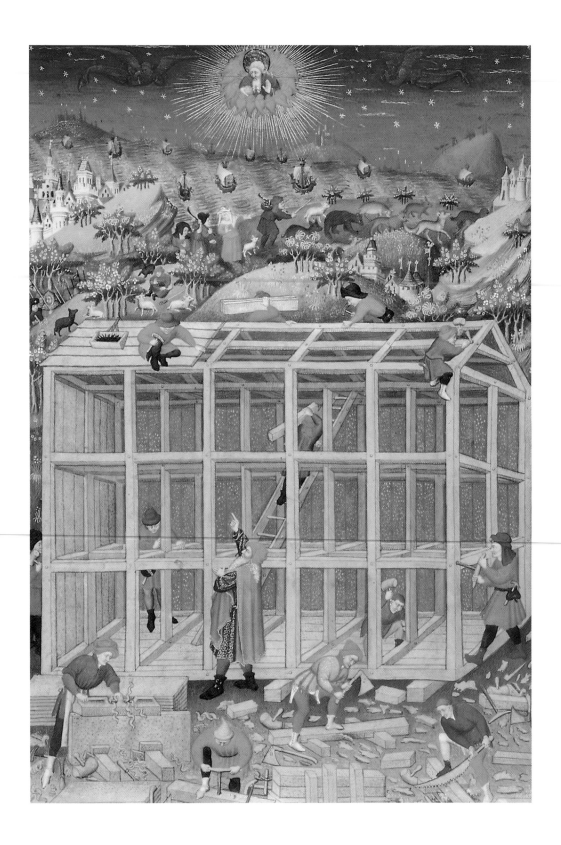

manuscript of a Romance of Alexander the Great (Fig. 38), shows Alexander building a city. Two masons are cutting stone with axes, and one of them is using a set-square: among tools lying on the ground are chisels, a wooden mallet, a set-square and a level. A labourer is carrying a hod of mortar up the ladder to the setter, working on top of the wall with a builder's trowel. A miniature from a manuscript written and illuminated in northern France in the early 14th century (Fig. 39), shows two masons chiselling lettering on tombs under the direction of a female patron; the picture illustrates an episode in a French prose version of the romance of the Holy Grail.

Mixing mortar, a combination of one part lime to two or three parts sand mixed with water, was an unskilled but important job. Fig. 40 shows a labourer mixing mortar in an open-sided shed: a water butt stands beside the shed and a second worker is carrying off a hod full of cement. The

Fig. 39 Masons. Romance of the Holy Grail. Northern France; early 14th century. *Royal MS 14 E III, f. 66 verso*

illustration is a detail from a miniature in the Bedford Hours depicting the building of the Tower of Babel.

Roof tiles were needed in large quantities, particularly in towns, where thatched roofs were frequently banned by the authorities because of the danger of fire. Building in brick became more common during the 15th century and bricks and tiles were made by similar methods. Clay was dug in the autumn and left to be broken up by the frost. In the spring the clay was moistened, flattened, and freed from loose stones; it was then packed into wooden moulds and left to dry before firing. A pen and ink drawing of a brickyard (Fig. 41) illustrates the story of the Israelites making bricks; the manuscript is a Bible History in Flemish, written in the Netherlands in the mid 15th century. The man at the table is moulding bricks, which are shown drying on racks, while the turretted building with flames shooting out of the door is the kiln.

Brick is being used for the country house under construction

Fig. 40 Mixing mortar. Bedford Hours (Building the Tower of Babel). Paris; about 1423. *Additional MS 18850, f. 17 verso (detail)*

Fig. 41 A brickyard. Bible History. Northern Netherlands; mid 15th century. *Additional MS 38122, f. 78 verso*

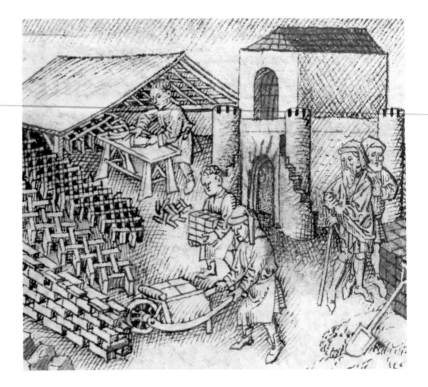

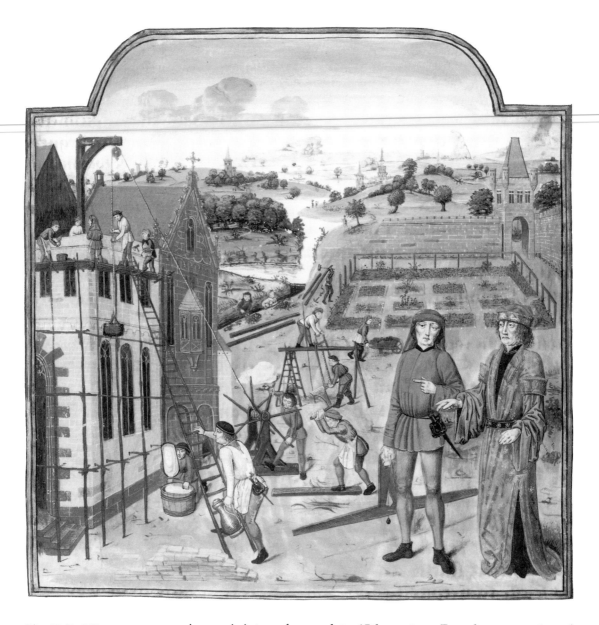

Fig. 42 Building a country house.
Petrus de Crescentiis, *Des profits ruraux des champs*. France; late 15th century. *Additional MS 19720, f. 27*

in a miniature from a late 15th-century French manuscript of *Des profits ruraux des champs* (Fig. 42). Details of the scaffolding and the hoisting machine are clear, and a plumb-level rests on the earth behind the standing figures in the right foreground. The man mounting the ladder is probably carrying water for damping the brickwork, while below the scaffolding a labourer is filling a hod with mortar. The sawyers and

carpenter are possibly preparing timber for the man fencing the garden. Sawyers worked in pairs: the timber is supported by a trestle and the upper sawyer is standing on the beam. Another method was to dig a pit; one sawyer stood in this, while the timber was placed across the top. In the background of the picture, two labourers are clearing a drainage channel, while a man with a barrow carts away the mud.

Roof tiles, and also slates, were hung by wooden pins driven through holes in the top of the tile; the tile was hung onto the roof lathe by the projecting part of the pin. To prevent water penetrating, tiles were overlapped, and could be bedded in moss; sometimes they were also pointed with mortar. Another illustration of the building of the Tower of Babel (PLATE V) shows men nailing on roof tiles.

The majority of medieval houses were of timber construction. A timber frame was made by carpenters, often at some distance from the building site; it was usually erected on a low stone foundation wall, as protection against damp, and the timbers were fixed together with wooden pegs. When the frame was erected, the spaces between the timbers were filled with wattle and daub. Upright stakes were interwoven with reeds, and daubed with mud or mortar; the surface was then plastered to give a smooth finish. PLATE VI, another miniature from the Bedford Hours, shows a timber frame building under construction, in this case Noah's Ark. In the foreground, two carpenters are preparing the timbers with axe and saw; a third is boring holes with a large drill, or auger, while a fourth uses a plane. Among tools on the ground are chisels and, beside the man with the saw, a brace and bit. A worker on the roof (right) is driving a wooden peg home to secure the roof timbers.

Fine timbered roofs were a particular feature of large English buildings, and contemporary building accounts give details of the work involved. The timbers for the new roof of Westminster Hall were worked at Farnham in Surrey; in 1395 carriage was paid for transporting these timbers by water from Farnham to Ham and by road to Westminster – a total of 52 cart journeys. The account roll of the master of the works also records payments to carpenters and to carvers employed on decorative work.

Carpenters were responsible for the finishing work to buildings, providing doors, floors, shutters, and interior panelling, as well as most furniture items. The Holy Family in the carpenter's workshop is the subject of a miniature in a 15th-century Spanish Book of Hours (Fig. 43). St Joseph is using a plane, while the array of tools hanging behind him includes a gimlet, and a pair of compasses. The Virgin Mary is busy with her embroidery work, a popular occupation for medieval ladies.

Glazed windows, which were not regularly fitted in houses of moderate status until the 15th century, were a standard feature of churches and other important buildings. Glaziers made leaded windows from sheet glass, and the manufacture of a large stained glass window required considerable skill. First, a pattern was made on parchment or direct onto a table. Each section was cut out as follows: a piece of glass of the right colour was put over the area of the pattern to be cut; the design was then traced, and cut along the tracing line with a hot iron rod, which caused the glass to crack. The glass could then be broken along the cracks and the edges finished off. At this stage the glass was painted if necessary, then fired to set the paint. Now, the window was ready for assembly. The pieces of glass were laid out in position on the pattern table and held down with T-headed nails; lead was then used to join the pieces together. When all the pieces were joined, the window was ready for fixing in the frame.

Although some glass was made in England, most supplies were imported. Glass was made from a fusion of sand and plant ash; the mixture, called frit, was placed in large pots or crucibles in the lower part of a wood burning furnace, so that the necessary chemical reaction could take place at a moderate heat. At this stage, glass could be coloured by adding substances to the frit, for example, copper for green. The frit was then moved to the centre of the furnace, where the temperature was high enough to melt the mixture. Molten material was withdrawn by the worker with the end of his blowing iron, a metal cylinder three to five feet long with a wooden mouthpiece. The molten glass was worked or 'marvered' into a cylindrical shape on a flat, smooth slab, often

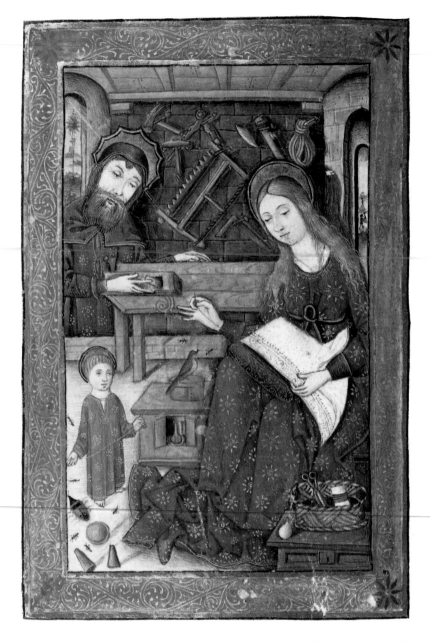

Fig. 43 St Joseph's workshop.
Book of Hours. Spain; second half of the 15th century.
Additional MS 18193, f. 48 verso

made of marble – hence the term 'marver' – and then blown and worked with shaping tools. The most efficient method of making sheet glass was to blow a long cylinder, which was cut at the end, sliced vertically and flattened. After blowing, the glass was cooled in an annealing chamber: this could be above, or alongside the main furnace. Glassworks were frequently established near a source of the necessary raw materials: sand, timber to fuel the furnace, and bracken, for example, to make

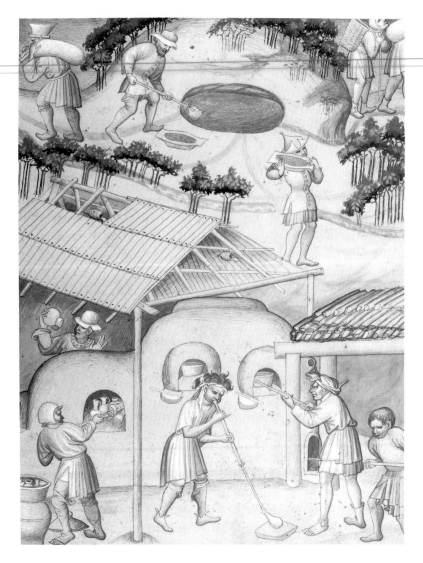

Fig. 44 Glass works in Bohemia.
The Travels of Sir John Mandeville. Austria or Bohemia; early 15th century.
Additional MS 24189, f. 16

the plant ash. The glass house needed to be fairly large to accommodate the workers, with their long blow pipes, around the furnace.

Fig. 44 shows a glass works in Bohemia. To the right, a boy stokes the furnace; on a platform above him is a stack of wood for fuel. One worker is extracting molten glass from the crucible with his pipe, a second is blowing and marvering, while

glassware cools in the annealing chamber to the left of the main furnace. Behind the furnace, the master of the glassworks inspects the finished products, while in the background labourers are quarrying and carrying away sand. The miniature is one of a series, executed by a Czech artist in the early 15th century, illustrating the Czech translation of *The Travels of Sir John Mandeville*, a story of journeying in the East that mingles fact with legend. The subject is the legendary pit of Memnon, where, according to Mandeville, the supply of sand was inexhaustible.

Cloth manufacture

During the 14th century, England replaced Flanders as the leading manufacturer of woollen cloth in Europe: the country had an abundant supply of raw wool, while fiscal measures of the English kings restricted cloth imports, and export of wool by foreign merchants. Throughout Europe, a great deal of cloth was made in the country or in small towns, and it was unusual for a workshop to carry out all the processes. A clothier might own a rural fulling mill, and put out his work to be spun and woven locally. He could then contract for specialist dyeing and finishing work, or sell the cloth unfinished. However, many urban weavers were organised in gilds and dealt directly in cloth, rather than carrying out piece-work for a wealthy clothier.

Processes used in woollen manufacture and in making other types of cloth were similar. First, wool had to be carded or combed, and spun – work that was invariably put out to be done at home by women. Carding and combing removed imperfect fibres and dirt and straightened the threads. The cards were rectangular wooden boards, each with a handle: one side was covered with leather, pierced with rows of teeth. Wool was placed on one card and the other card was drawn gently across it. This process was repeated until the wool was of a suitable texture for spinning. Originally, the work was done with teazle heads (the term 'card' comes from the Latin word for a thistle (*carduus*)). Wool from long-haired sheep, and flax,

Fig. 45 Carding, spinning and weaving.
Boccaccio, *Le livre des cleres et nobles femmes*.
France; early 15th century.
Royal MS 16 G V, f. 56

78

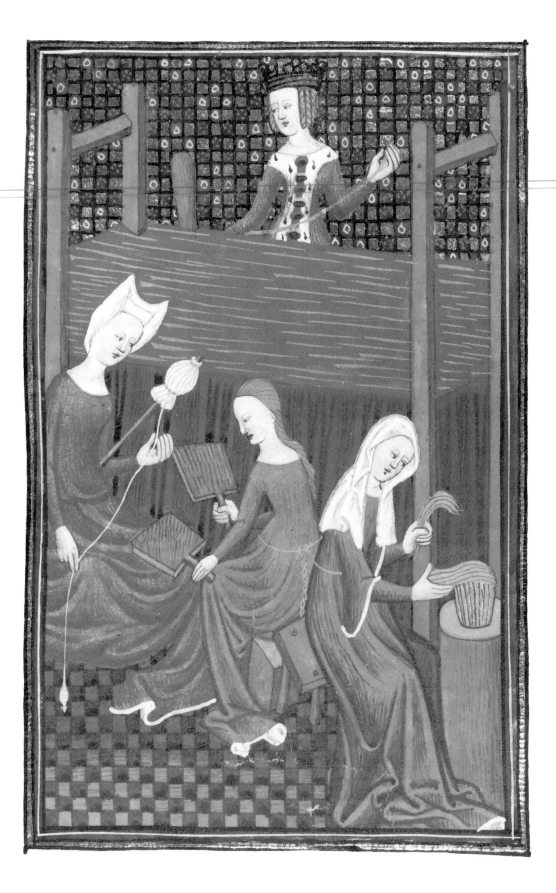

was drawn through the teeth of a metal comb. Fig. 45, another miniature from a manuscript of Boccaccio's *Le livre des cleres et nobles femmes*, shows a woman holding two cards, while another is combing: the woman seated to the left is working with a hand spindle. This was a cylindrical object, tapered at both ends, and with a notch at the top to guide the thread; a weight or whorl, often of clay or stone, was added at the bottom to improve rotation. Fibres to be spun were stored on a distaff, which was held under the spinner's left arm. The thread was pulled out with the left hand, while the right hand rotated the spindle.

Faster work was possible with the spinning wheel, introduced to Europe from the East during the 13th century. A spindle, which was attached to the wheel, was mounted horizontally onto the wheel table; the operator manipulated the thread with the left hand and rotated the wheel with the right. In Fig. 46, a marginal illustration from the Smithfield Decretals, the spinner is a man: perhaps he is demonstrating the advantages of the new technology to his female companion.

Weaving was the most important part of the cloth-making process. A loom needed to do two things: firstly, to hold tense the long thread, or warp; secondly, to take up, or roll, the finished cloth. Ancient looms, of the kind used in Anglo-Saxon England, had vertical frames; often the warp was held tense by loom weights at the bottom of the threads. However, by the

Fig. 46 The spinning wheel. Smithfield Decretals. England; early 14th century. *Royal MS 10 E IV, f. 147 verso*

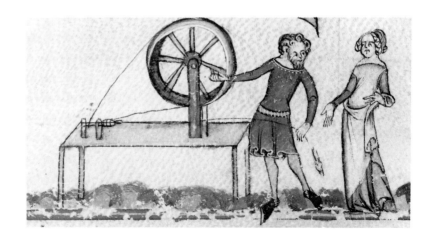

13th century, the horizontal framed loom was used all over Europe: with this type of loom it was possible to make wider, firmer, cloth, and to introduce a variety of patterns. The weaver sat at the frame and the cloth was rolled on the beam nearest to him, while the warp was attached to the far beam. The warp threads were separated into different series by heddles; the heddle was a device consisting of upper and lower rods joined with looped cords. The warp was passed through loops in the heddles so that the threads could be raised and lowered in sequence, most conveniently by a treadle, to create the weaving pattern. The weaver then passed the short thread, or weft, through the gap, and struck the thread into place with a reed, a comb-like object. The heddles can be seen clearly in an illustration of a treadle loom from the Egerton Genesis (Fig. 47). The weaver is Naamah, daughter of Lamech (the story that Naamah invented weaving is probably medieval in origin). The artist of the Boccaccio manuscript (*see* Fig. 45), however, does not show the technical details of the loom used by the weaver in the background of the miniature. Although both these illustrations show women weavers, many professional workers were male, for considerable strength was needed to strike the weft into place when making wide cloth of firm texture. The upright loom or frame continued to be used for making woven and embroidered tapestries. Another miniature from the Italian Old Testament Picture Book (PLATE VII), shows two men making hangings: the tapestry here is stretched on a frame, attached at about every fifth thread.

Cloth could be used immediately after weaving, but finishing processes produced a better quality article. Fulling, for example, shrinks the loose fibres of the cloth and therefore improves density. The cloth was beaten in water which contained a cleaning agent such as fullers earth: this process removed the oil with which wool was treated. The original method of fulling was to trample the cloth underfoot in troughs, but by the 13th century the fulling mill, where cloth was beaten by hammers operated by water power, was common. After fulling, the cloth was stretched out to dry in the tenterfields; these fields are often mentioned in medieval town records. Unfortunately there was always the temptation, if the

Fig. 47 Weaving.
Egerton Genesis. England;
about 1350–75.
Egerton MS 1894, f. 2 verso
(detail)

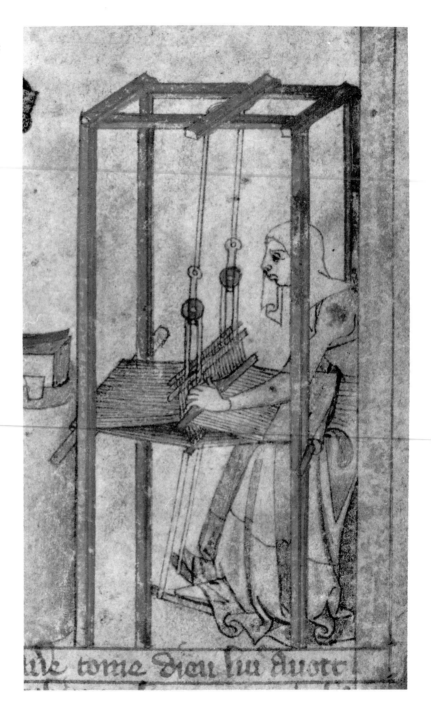

fuller owned the cloth himself, to stretch the material too far, thus weakening the cloth.

Dyeing was a specialist trade, usually carried on in town. Processes varied, according to the cloth to be dyed and the dye used: preparing the dye was an art in itself and dyers guarded their secrets closely. Apart from the colouring matter, a fixing agent, or mordant, had to be used to set the dye: this was frequently alum. Fig. 48, an illustration to Bartholomaeus Anglicus, shows cloth being dyed in a huge kettle set over a fire; the cloth was lowered into the kettle on wooden bars. This miniature reveals a degree of artist's licence. It is most unlikely that a finished bale of cloth would have been left on the ground next to a boiling vat.

Fig. 48 Dyeing. Bartholomaeus Anglicus, *Des proprietez des choses.* Bruges; 1482. *Royal MS 15 E III, f. 269*

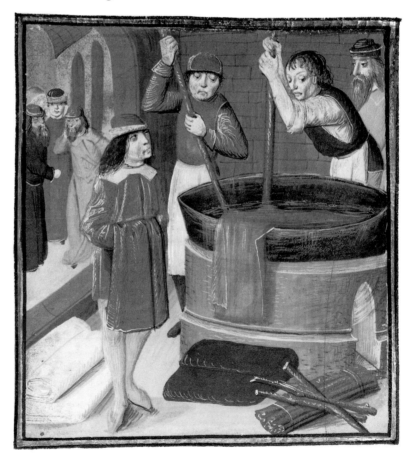

Repeated rinsing and redipping made a great deal of wet mess, particularly annoying to neighbours. In 1357, a couple living next door to a dye works in the City of London complained by Assize of Nuisance that steps on their property were used by dye-workers carrying wet cloths: so much water ran into their tenement that, they claimed, it was rotting the foundations.

The fulled and dyed cloth was now ready for the final stages of finishing. First, the material was brushed with teazles to raise the pile, then loose threads were cut off by the shearer. Shearing was extremely skilled work, since the surface quality of the cloth depended upon the worker's dexterity. A shearer with his shears on his shoulder is a member of a group of workmen illustrated in a mid 15th-century French manuscript (Fig. 49). This miniature, one of three showing the estates of the

Fig. 49 Group of workmen.
Boccaccio, *Des cas des nobles hommes et femmes malheureux*. France; mid 15th century.
Additional MS 18750, f. 3

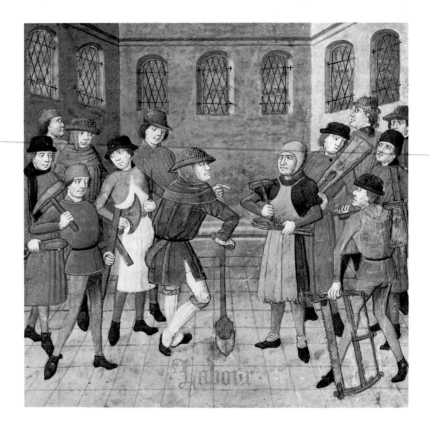

realm, is part of the frontispiece to *Des cas des nobles hommes et femmes* ('The downfall of noble men and women'), a French translation of a Latin work by Boccaccio. Other craftsmen shown are, from left to right, a tailor, a mason, a metalworker, an agricultural labourer, a smith (in hood and apron), and a carpenter.

Leather

Leather was used to make many everyday items; jerkins and belts, shoes and gloves, saddles and harness, bottles and buckets. To check putrefaction, hides can simply be cleaned and dried, then moulded when wet, but the finished article, rawhide, will be stiff. In the middle ages two main methods of treatment, tawing and tanning, were used to arrest decay and soften hides.

The first stage of treatment was to clean the skins. The hides were soaked in lime-water, then scraped over a board with a curved knife to remove hair, the outer skin or epidermis, and fat. Fig. 50, a detail from a manuscript produced in Germany in

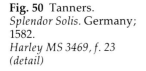

Fig. 50 Tanners. *Splendor Solis.* Germany; 1582. *Harley MS 3469, f. 23 (detail)*

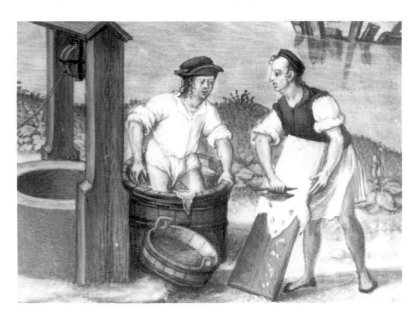

1582 (*see* below p. 94), shows a tanner scraping a pig-skin, while his companion tramples skins in a barrel; note the piece of hide hanging over the edge of the tub. The white-tawyers treated cleaned skins with alum and oil, which produced a hard, white leather. Tanners soaked the hides for as long as a year in pits or vats containing the tanning agent, a liquor made from oak bark. Attempts were made to regulate the division between the two trades: skins of deer, goats and horses were supposed to be tawed, while ox, cow or calf hides were tanned. The skinners, whose trade was in furs, treated the flesh side of pelts with an alum and salt solution.

After tanning, the skins were finished by curriers or leather-dressers; the hides were dressed with oils and might need smoothing, or even thinning, with knives. The leather was then ready for the craftsmen who produced finished articles – for example saddlers, shoemakers and bookbinders.

Salt

Salt was a vital commodity to medieval man. Large quantities were used in cheese and butter making, and in preserving meat supplies for winter food. In particular, fish had to be cured as soon as possible after it was caught, and dried, smoked or salted fish was an important part of the medieval diet.

Salt was obtained from the sea or from brine springs associated with rock salt deposits. Sea water was drawn off into pools where it was left for the water to evaporate, leaving behind the crystallized salt. This method was ideal where the sun was strong, for example, on the southern Atlantic coast of France. In northern Europe, however, where the weather was not so kind, the partially evaporated salt water was drawn off and the process completed by boiling. Where the salt industry was based upon rock salt deposits, for example at Droitwich in Worcestershire, and at Lüneburg and Halle in North Germany, the brine was tapped and extracted through pipes to be boiled in the salt house.

The salt house was a shed, open on one or two sides. The brine was boiled in large cauldrons until the salt had

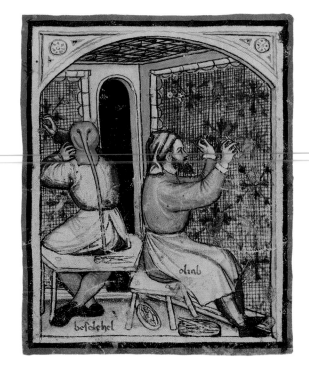

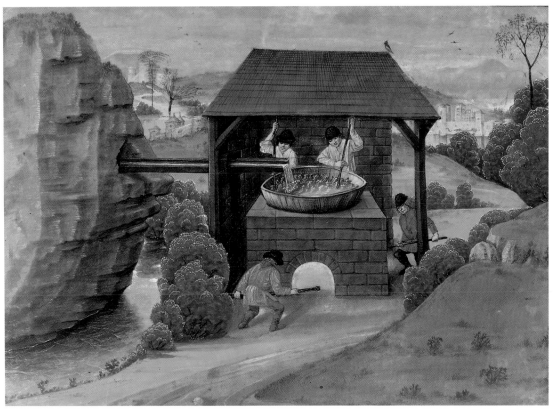

kl' Ignacij epi.

xvij · · kl'

vj · b · k Graciam episcopi

· c · kl' Anniua

xiiij · d · kl vigilia

iij · e · kl Thome apostoli

· f · kl' Didime niu̅

vj · g · kl' Victone virginis

· · kl' Vigil'

xix · b · kl Natiuitas dñi.

vij · c · kl Stephani pthom

· d · kl Johis apli τ euang

xvj · e · kl scor̅ Innocentiu3

v · f · kl Thome cantuar

· g · kl' Dauid reg

xiij · · kl Siluestri pape

crystallized on top of the water and could be skimmed off with
a shovel. The salt was then piled into wicker baskets and left
to dry in the sheds. A miniature from 'Le Trésor des Histoires'
(PLATE VIII), a universal history and encyclopaedia, illustrates the
chapter on Saxony in a section giving a geographical account of
the provinces of the world. The picture shows salt making in
Saxony: two salters are stirring the brine, which runs direct
into the cauldron through a convenient pipe. The manuscript
was executed in the Southern Netherlands around 1470–80.

Victualling and services

Urban dwellers, who were not food producers and generally
lacked extensive storage and kitchen space, needed specialists
to provide their food. Work that a country family might do at
home, like killing and salting down a pig or baking bread, was
therefore the job of the town craftsman, the butcher, baker or
cook. Certain activities, when carried out as commercial ven-
tures, caused problems in town; in 1345, a complaint was made
in the London Husting Court that brewers were taking so much
water from the Conduit in Cheapside that there was not
sufficient for domestic use. Butchers, however, were the vic-
tuallers who caused most complaint.

Killing one or two animals in the country posed no prob-
lem; any unwanted refuse could easily be burnt or buried. On
the other hand, urban slaughter houses, and scalding houses
where the carcases of animals were cleaned with boiling water,
were a frequent source of complaint. For example, the Friars
Minor in London complained, by Assize of Nuisance in 1370,
that the filth and blood from carcases in the scalding house of a
butcher in the parish of St Nicholas Shambles ran out into the
street gutter and thence through the friars' garden. In response
to such complaints, the authorities tried to prevent slaughter
within the city limits and ordered that butchers' refuse should
be thrown into the Thames at ebb tide. An illustration to the
December calendar entry in a late 15th-century Flemish Book of
Hours (PLATE IX) shows the tidier side of the medieval meat
trade. One butcher is chopping up a large joint, while a second,

with an array of knives in his belt, is salting down meat in a barrel. Outside, joints are on sale on tables in preparation for the coming festive season.

Salted and cured meat and fish, beer and wine were stored in barrels, and the manufacturer of these barrels was the work of the cooper. The rounded barrels were made of separate staves, held together by hoops, and the making of these utilitarian objects was a skilled craft. In particular, if liquid was to be stored, the barrels had to be very strong: they must not leak, they must withstand internal pressure caused by fermentation, and also transportation, often over long distances. Each stave was curved: after cutting, the staves were fixed together at the bottom with temporary hoops, then drawn into their final shape with ropes. Fig. 51 shows one cooper working

Fig. 51 Coopers.
Book of Hours. Italy; early
16th century.
Yates Thompson MS 30, f. 8

on a hoop, while another finishes off the top of a barrel: the miniature is the August calendar illustration to a Book of Hours written and illuminated in Italy early in the 16th century.

Bread, of course, was a major item in the medieval diet. A great household could maintain its own bakery, and while many people baked their bread at home, most townsmen, by necessity or for convenience, bought bread from a professional baker. Dough was mixed in a large trough and the loaves were cooked in a beehive-shaped oven, which could be freestanding. A wood fire was lit in the oven cavity. When the oven was hot the ash was raked out, falling through a slot in the threshold of the oven just outside the door, to an ash hole at ground level. In an illustration from the Smithfield Decretals (Fig. 52), one man is shaping loaves, which a second baker puts in the oven with his long-handled shovel or bat. The ash hole can be seen at the foot of the oven. Ovens of this type, often built alongside or behind a kitchen hearth, were used in England until the 19th century.

Cooks and piemakers naturally used ovens for baking their pies and meats. The professional cook in the middle ages might be an individual employed in a small household or one of dozens in a big establishment: commercially, he might own, or work in, a tavern or cookshop. The cookshop was the ancestor of the public eating house and the modern take-away, and cooks are mentioned in early urban records. Customers could buy a variety of meats and pies to eat at home, or even have their own meat cooked: the list of prices fixed by the City of London authorities in 1378 includes pig, goose, capons, hens and pullets, mallard and teal, snipe and woodcock, larks,

Fig. 52 Baking bread. Smithfield Decretals. England; early 14th century. *Royal MS 10 E IV, f. 145 verso*

partridge, plover and pigeons. The most expensive roast meats were bittern at 20*d.* each, heron 18*d.* and pheasant 13*d.*, while the cheapest items were 10 finches for 1*d.* and 10 eggs for 1*d.* Prices are also listed for cooking the customers' own meats in a paste: similar to suet crust, paste was used for puddings or wrapped around meat or poultry before boiling or baking. London ordinances regulated trade practices: in particular, cooks and piemen were forbidden to use offal as a pie filling, to represent beef as venison or to cook meat twice for sale. Given the nature of the trade, it is not surprising that complaints are recorded about bad food. In 1355, a chaplain complained at the Mayor's Court in London that a cook had sold him stinking, reheated veal for his supper on the previous evening. In this case the veal was produced in court, and after a thorough inspection the cook was acquitted. However, in 1351 another offender was not so lucky: the putrid capon he had put in a pastie was carried before him on the way to the pillory.

An illustration (Fig. 53) from a mid 14th-century Flemish manuscript of a Romance of Alexander the Great shows a group of cooks at work, preparing the feast for a marriage mentioned in the adjacent text. From the left, the first figure is pounding meat to tenderize it, and the next cook is probably making a paste. Two small cauldrons stand on the edge of the fire, each containing an inner saucepan, perhaps for stew or soup. The large cauldron would probably have held a variety of food, rather than one large dish; for example, parcels of bacon, puddings or boiling fowl in paste, all wrapped in linen cloths, eggs, onions, and other vegetables. To the right, a kitchen boy is turning roast fowls on a spit over the fire, while two cooks baste the birds with long spoons.

Fig. 54 *(opposite)* Laundresses. *Splendor Solis.* Germany; 1582. *Harley MS 3469, f. 32 verso*

Fig. 53 Preparing a feast. Romance of Alexander the Great. Southern Netherlands, probably Bruges; about 1344. *Bodleian Library Oxford, MS 264, f. 170 verso*

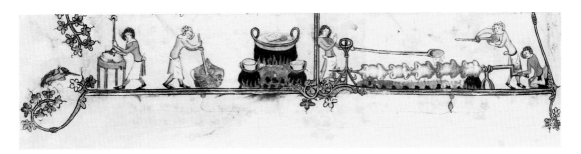

Laundresses (Fig. 54) were a group of workers who provided a personal service for others, either as household servants, or as part of a business venture. The *Splendor Solis* ('Splendour of the Sun') is an alchemical text with a second, mystical meaning, illustrated with a series of allegorical pictures. Written in Germany in 1582, this manuscript is not strictly medieval. However, it seems unlikely that laundresses had altered their methods greatly during the sixteenth century.

Chapter 4

The professions

The church

PLATE X Friars singing in choir.
Psalter. Paris; early 15th century.
Cotton MS Domitian A XVII, f. 122 verso (detail)

From a purely materialistic viewpoint, a career in the medieval church as a secular priest provided a secure living, with many job opportunities. For some men the prospects were glittering. Bishops who did not come from a wealthy background often had a previous career as a diocesan administrator, a civil servant or at a university; an example of such a man was the Franciscan scholar, Robert Grosseteste, who became bishop of Lincoln in 1235.

The ideal of the priesthood set a young man with a vocation the highest standards, and if he were a parish priest his duties, set out in contemporary manuals, could be heavy. First, he had to keep himself worthy of his calling, by leading an abstemious life, with frequent prayer and examination of conscience. He had to say the canonical hours daily, and celebrate mass. Fig. 55 shows a priest saying mass, elevating the Host after consecration. Behind him kneels an acolyte with a candle. The miniature is from a Breviary, the book containing the prayers, psalms and readings for the daily Hours of the church's public liturgy, made in Paris in the early 15th century. The picture illustrates the prayers for Corpus Christi ('the Body of Christ'), the feast of the Blessed Sacrament. If the priest had cure of souls, he was obliged to conduct baptisms and funerals, and to visit the sick. Further, it was his duty to instruct his parishioners in the Faith, usually by means of sermons, and by detailed examination of conscience in confession, compulsory at Easter.

Illustrations in a Book of Hours produced in Paris in the mid 15th century show some of a priest's functions. Two small pictures from an illuminated page introducing the Hours of the Holy Spirit depict baptism and confession. In the first (Fig. 56), the priest pours water over a naked baby, held struggling over the font by his godfather. The assisting clerk holds towels and a box for the oils used in the service. In the second (Fig. 57) a woman kneels to confess at the feet of a friar. The Holy Spirit appears in both pictures in the form of a dove. In the same manuscript, the Office of the Dead is introduced by a miniature showing a burial (Fig. 58). Two grave diggers are lowering the corpse, wrapped in a sheet, into the grave; the spade to be used for shovelling in the earth lies ready to hand. The officiating priest is sprinkling the corpse with Holy Water. In the

Fig. 55 *(page 101)*
Celebrating mass.
Breviary. Paris; early 15th century.
Harley MS 2897, f. 211 verso

96

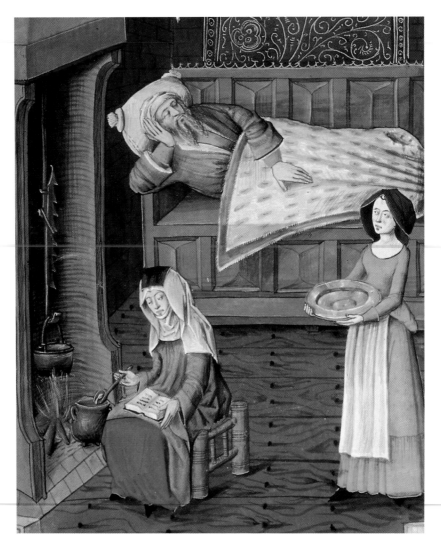

PLATE XI (ABOVE) Lay-sister
preparing medicine.
Guyart des Moulins, *Bible
Historiale*. Bruges; 1470.
Royal MS 15 D I, f. 18 (detail)

PLATE XII (LEFT) Disciplining
scholars.
Priscian, *Grammatica*. France;
early 14th century.
Burney MS 275, f. 94

PLATE XIV (OVERLEAF) A law
court.
Valerius Maximus, *Faits et dits
mémorables*. France; mid 15th
century.
Harley MS 4375, f. 138 verso

PLATE XIII A scholar in his study.
Valerius Maximus, *Faits et dits mémorables*. Bruges; 1479
Royal MS 18 E III, f. 24

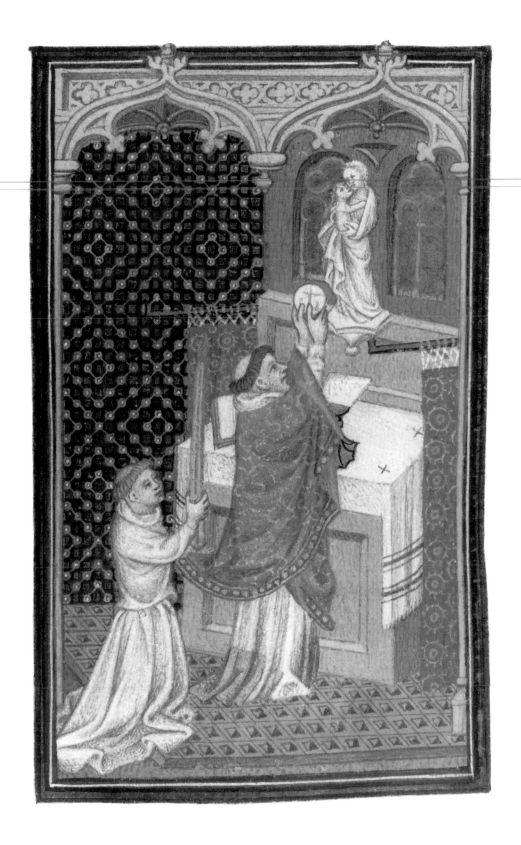

Fig. 56 Baptism. Book of Hours. Paris; mid 15th century. *Egerton MS 2019, f. 135 (detail)*

background, a row of skulls peer from the charnel house, and St Michael is winning his struggle with the Devil for the soul of the deceased.

There was no formal training for the priesthood in the middle ages. Candidates for ordination, who were examined by the bishop's representative, acquired their knowledge in various ways: a minority studied at university; some boys might be educated at a cathedral or monastic school; others learned Latin, and gained familiarity with the liturgy by acting as choir boys; the majority probably assisted in their parish church, receiving their education and instruction from the parish priest and parish clerk. A candidate for the priesthood was ordained in eight stages, culminating in the major orders, sub-deacon, deacon and priest. A boy who took the five minor orders did not have to proceed to the priesthood, and was free to marry. He could also use his clerical skills to earn his living, as a parish clerk, a copyist, or, like William Langland the poet, he could be hired by patrons to sing psalms for the souls of their dead relatives.

Once ordained, the new priest faced the difficulty of finding

Fig. 57 Confession. Book of Hours. Paris; mid 15th century.
Egerton MS 2019, f. 135 (detail)

his first job. Parish livings were in the gift of a patron, such as a bishop, the Crown, an Oxford or Cambridge college, a religious house or a local landowner, and unless a man had studied at university or was socially well connected it was unlikely that he would become a parish priest at once. However, absenteeism and pluralism, the practice of holding more than one job at a time, meant that he might obtain a post as a stipendiary priest. For example, a bishop's chaplain or ecclesiastical lawyer might, in addition, be made rector of a parish in the diocese. Wishing to concentrate on those aspects of his career that would bring greater material rewards in the long run, he collected the income from the parish and paid a stipendiary a small annual salary to carry out the duties of parish priest. Stipendiaries were also appointed as assistant priests in large parishes. Alternatively, a man might become either chaplain to a gild, or a chantry priest, employed regularly to pray for the souls of the dead under the terms of the chantry's foundation. Some priests eked out a living on a casual basis, saying masses for the dead and helping out in parishes at busy times, for instance, hearing confessions at Easter.

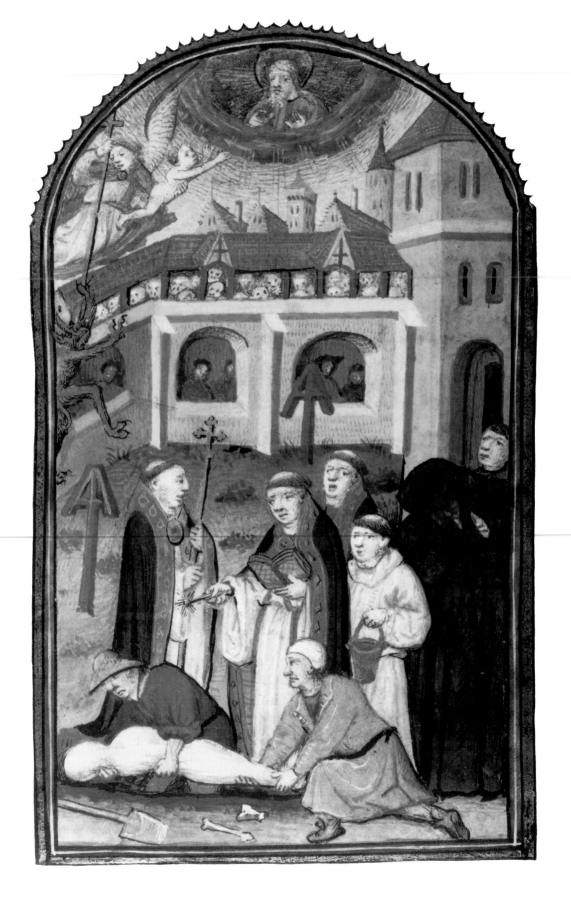

Fig. 58 Burial.
Book of Hours. Paris; mid
15th century.
Egerton MS 2019, f. 142

Complaints about the behaviour of the clergy abound in records and literature. Langland writes of priests who neglect the cure of souls, thronging London to sing masses for silver. However, cases of indiscipline that reached the records were probably the worst examples. In general, parish clergy, while not illiterate, were certainly not well educated. Indeed, the preferment system did not encourage a learned man to remain a parish priest, particularly in a poor country parish. Chaucer in *The Canterbury Tales* and Langland in *Piers Plowman* depict two very different parish priests. The former, a poor town parson, '. . . a lerned man, a clerk That Cristes gospel trewely wolde preche', cares for his people diligently and patiently, teaches, visits the sick, and does not press the poor for his tithes. In contrast, Langland's slothful priest cannot sing properly, or read saints' lives or canon law, although he has been a parish priest for 30 years. A surly cheat and a swindler, he is better at chasing hares than saying the psalms. Perhaps the norm lay somewhere between the extremes of these two characters.

The religious orders

The religious life – to be a monk or friar living in a community – was, of course, open to both men and women. The new recruit, who may have been educated in the monastic school, was trained by the master of the novices until he was admitted a full member of the community. St Benedict, the founder of European monasticism, was of the opinion that idleness was the enemy of the soul, and the Benedictine Rule, which influenced the practice of other religious orders, divided the monk's working hours into periods of prayer, study and work.

Prayer and worship were important activities in a monastery, and singing the Divine Office usually took precedence over all other work. The monks rose in the middle of the night to say the Night Office, Matins and Lauds. Prime either followed the Night Office or was said at daybreak, according to the season, and the morning was occupied with Terce, Sext and None, attendance at mass, work and study. A miniature from a

Psalter made in Paris in the early 15th century (PLATE X), shows friars singing in choir. Dinner was normally eaten around 2 p.m., followed by further work or study until vespers and compline in the early evening and bed, at about 7 p.m. in the winter months. However, it was possible to modify observance of the Office in individual cases. For example, some monks had heavy administrative tasks, particularly in the larger houses that owned extensive estates.

The work a monk did varied according to his capabilities and the order to which he belonged. Brothers with the ability, who were not occupied with teaching or administrative duties, copied, illuminated and bound books needed in the library and for services (*see* pp. 109–112). While the whole community worked in the fields at busy times, such as at harvest, most manual work was done by monastic servants, labourers, or the less well-educated among the brethren. The Cistercians, for example, admitted lay brothers to their order as full members of the community, but with separate duties. The obligation laid upon all monks to read and study became for some a lifetime's work of scholarship. Indeed, the order of Dominican friars set learning and defence of the Faith as their first objective. In contrast, the Franciscan friars were dedicated to a life of poverty, preaching and service to men. Initially, the friars lived in small groups; they settled in towns, where their preaching reached a large audience, and they became popular as confessors (*see* Fig. 57).

Practical work on behalf of their fellow men was the duty of the brothers and sisters who staffed the hospitals. The medieval hospital developed from the monastic tradition of extending hospitality to travellers. Hospitals also accommodated poor, sick people who had no one to care for them, and some hospitals specialised, looking after lepers, for example, or the infirm aged. Lay brothers and sisters nursed the sick, helped by servants. A sister preparing medicine by a fire appears in a miniature from a Bible History in French (PLATE XI), illustrating the story of Tobit, who was unfortunately blinded by birds' excrement. The manuscript, vol. iv of *La Bible Historiale* of Guyart des Moulins, was written and illuminated in Bruges in 1470.

Scholars and scribes

Education in the middle ages was chiefly controlled by the church, which had a natural interest in promoting literacy and learning: indeed, the Emperor Charlemagne in the eighth century had decreed that all monasteries and bishops' residences should maintain a school, in order that future clerics and monks should be well educated. To this end, cathedrals and monasteries kept schools for choristers, for their own clergy and novices, and for boys of the neighbourhood, while elementary education was also provided in small schools maintained by parish and chantry priests. Throughout the period, most teachers were clerics, although this was not always the case.

The study of Latin was important for the church and the law, since most texts and documents, as well as church services, were in that language. Moreover, a thorough knowledge of the language was necessary if a boy wished to attend university, where the lectures were given in Latin. In order to learn Latin grammar, a boy needed to attend a 'grammar' school, run by a cathedral or by a monastery, like the school attached to Westminster Abbey. Schools were also set up in towns by the municipal authorities in the later middle ages, and in England two independent, charitable schools of high quality were established: Winchester, founded by William of Wykeham, Bishop of Winchester, in the reign of Richard II, and Eton, set up by Henry VI in 1440.

Secondary education was based on study of the three minor arts: firstly grammar, which at best included the background and subject matter of texts studied, as well as language; secondly logic, the science of reasoning, and thirdly rhetoric, the art of oratory and persuasion. A student who had mastered these subjects went on to study the four major arts, arithmetic, geometry, astronomy and music, before proceeding to advanced work in theology, law or medicine. In the early middle ages, almost all this work was usually done in monastic or cathedral schools: some schools simply taught grammar, while others taught the whole range of arts subjects and specialised in some branch of advanced work. By the 12th century,

students travelled all over Europe to attend the more famous schools, and it was from these schools that the medieval university developed. Bologna was celebrated for law and Salerno for medicine, while in northern Europe scholars flocked to the cathedral schools of Paris in the early 12th century to study arts, the philosophy of Aristotle and theology, attracted in particular by the great master, Peter Abelard. The schools of Oxford were well established by the end of the 12th century and Cambridge developed initially because scholars migrated from Oxford and Paris in the early 13th century.

A student going to Oxford or Paris in the 13th century chose his own master. Lectures were given in hired rooms and the wise student would sample the lectures and take advice before committing himself. He found his own lodgings in the town or joined with other students in renting a hall, a lodging house administered by the residents, usually under the supervision of one of the senior students, who was responsible for the rent. Members of religious orders, for example the Franciscans at Oxford, lived in their own houses. The Oxford and Cambridge colleges were originally foundations endowed to support a group of graduate scholars doing advanced work, like All Souls College at Oxford today. Studies for a master of arts degree took about seven years and the majority of students did not complete the course: some left when they had acquired sufficient knowledge and contacts to further their career; others migrated to a different university. Only a handful proceeded to higher studies in theology, medicine or law.

Discipline was a problem, not only with school boys but also in the universities, where boys as young as 13 were admitted as undergraduates. In 16th-century Oxford, a man taking a degree in grammar was invested with a birch and a 'palmer', a stick with a round, flat head, specially designed for slapping hands. PLATE XII shows a palmer in use. The female figure to the left holds a branch, symbolising good and bad forms of speech. The miniature illustrates Priscian's Grammar, which was used widely in the middle ages; the work is part of a volume of students' texts and the manuscript was executed in France in the early 14th century.

The students shown attending a lecture (Fig. 59) are

Fig. 59 Medical lecture. Bartholomaeus Anglicus, *Des proprietez des choses.* France; early 15th century. *Royal MS 17 E III, f. 36*

studying medicine: on the shelf, apparently suspended from the ceiling, are flasks for urine samples and beakers for blood. The miniature, from a manuscript written and illuminated in France in the early 15th century, illustrates the chapter on the elements of the human body from a French translation of Bartholomaeus Anglicus. An illustration (PLATE XIII) from *Faits et dits mémorables* ('Memorable sayings and acts'), a French translation of a popular collection of anecdotes by the Roman writer Valerius Maximus, shows the translator at work in his study. The writer is working at a drawing board. His page is held to the board by weighted cords and his books and other goods are visible in the open wall cupboards. The date at which the manuscript was made, at Bruges in 1479, is inscribed on the back wall.

The monasteries were the chief centres of book production until around 1200: their aim was to produce texts needed by the community for study and worship. In illustrations, the scribe is frequently shown writing in a bound book. However, the normal process was to work on a folded quire of parchment; when the work was completed, the quires were bound into a

volume. Parchment was usually made from sheep, goat or calf skin; the skins were soaked, scraped to remove hair and fat, stretched, and rubbed down to smooth the surface. The scribe carried out the final stages of preparation himself. The skins were cut to size and polished with a pumice stone. Then the writer ruled the pages, making prickings down the side of each margin with an awl, and joining them together with a lead pointer or a stylus with a blunt metal point. Usually, the scribe wrote with a sharpened goose or swan's quill, while crows' quills were used for fine work. Miniatures show writers with a pen in one hand and a knife in the other; the knife was used to smooth the rough surface of the parchment and to hold the page flat. The writer, dressed as a cleric, shown in Fig. 60, may be collating newly completed work with the original to check for mistakes. His page is placed on a writing board, balanced on the arms of his high backed chair. The weighted cords, used to hold the parchment flat, rest on the board. The miniature,

Fig. 60 Scribe. Vincent of Beauvais, *Le miroir historiale*. France; early 15th century. *Lansdowne MS 1179, f. 34 verso*

Fig. 61 *(opposite)* Artist. Boccaccio, *Le livre des cleres et nobles femmes*. France; early 15th century. *Royal MS 16 G V, f. 73 verso*

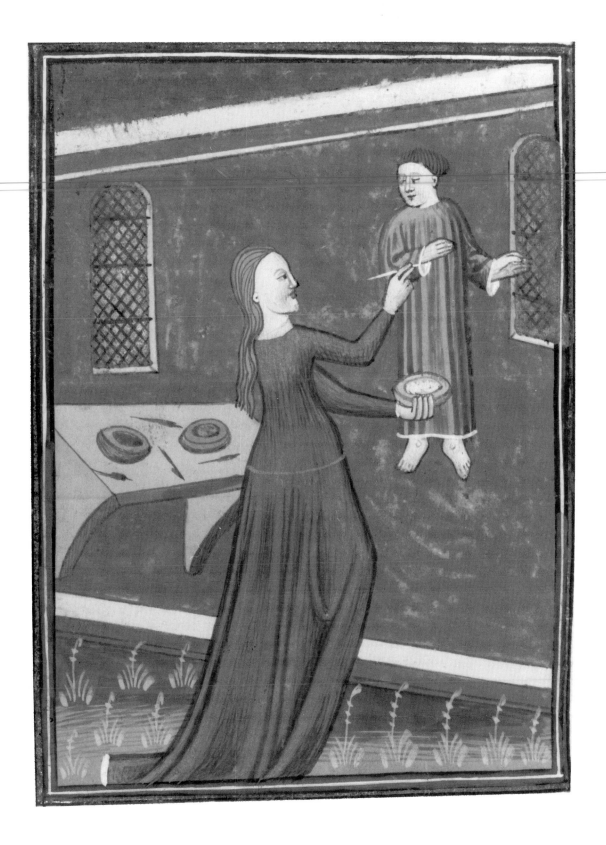

from a manuscript produced in France in the early 15th century, illustrates a chapter on the works of Seneca from a French translation of the *Speculum Historiale* ('The Mirror of History') of Vincent of Beauvais.

By the 13th century, the monasteries could not satisfy the demand for books caused by the spread of literacy, the increase in student numbers and the development of the universities. Secular workshops in towns produced a variety of manuscripts: works needed by students, for example legal and grammatical texts; small pocket Bibles for individual use; books of personal devotion, such as Psalters and Books of Hours, and vernacular histories and romances. On a more mundane level, numerous scribes earned a living writing the documents needed for administrative, business and legal purposes. London, Oxford and Paris were major centres for the book trade, and some workshops were celebrated for the production of high-quality illuminated manuscripts. A number of medieval illuminators and artists were women: another miniature from a manuscript of Boccaccio's *Le livre des cleres et nobles femmes* (Fig. 61), shows a woman working on a wall painting. This illustration is not entirely realistic: the desk on which the artist's brushes and palettes rest has no visible means of support and the hand of the painted figure overlaps the window.

The law

Unlike the priest, a young man beginning a career as a lawyer did not have to forego the pleasures of marriage and family life. For the able and ambitious the financial rewards could be great, while the law offered opportunities for advancement to men of moderate means, provided they could afford the expenses of training. The legal profession developed from the practice of allowing a litigant to bring friends to court to advise him, or even to speak for him if, for instance, he was sick. Similarly, a man could appoint an attorney, who might be a friend or relative, to act on his behalf, for example, to take possession of a piece of land he had bought. The increasing complexity of the

law, however, made it advisable to hire a man with specialist knowledge to give advice, to plead in court, or, like a modern solicitor, to initiate legal processes.

In 15th-century England, a youth wishing to study law would enter one of the Inns of Court or Chancery, situated to the west of the City in Holborn or the Strand. The Inns are first mentioned in the mid 14th century but it is possible that hostels for law students had existed in the area for some time. Training consisted of attending the law courts at Westminster during Term time, and reading; unless he attained high office, a lawyer remained a member of his Inn throughout his career. However, not all young men entering the Inns intended to make their living from the law. Legal knowledge was important for a man of property, and by the 15th century the custom was established among the gentry of sending their sons to the Inns for a period, not only to study but as a kind of finishing school, where they met their contemporaries from all over the country.

The young lawyer was most likely to work as an attorney in London, or the provinces; in this capacity he would undertake the necessary steps in legal action that were required in his client's case, and instruct counsel. Alternatively, the trainee might work as an apprentice pleader, or barrister, although the division was not complete between the two branches of the profession and one man might work as both pleader and attorney. Apart from being hired to work on specific cases, attorneys and pleaders could be retained by clients for a relatively small annual fee, which secured the lawyer's interest and goodwill; a bishop or a provincial city, for example, might retain an attorney to look after their affairs at Westminster. Further, a lawyer could become an official of one of the central courts, for instance the Court of Common Pleas, which dealt with disputes between subjects.

At the head of the profession were the judges, appointed by the King. Originally, the judges were members of the King's council, but as the volume and complexity of business increased, it became the practice to appoint men with special knowledge, and by the end of the middle ages it was customary for the judiciary to be appointed from among the senior barristers. Some judges became very wealthy and unfortunately

the temptation to take bribes proved too much for certain
men. In 1289, as the result of an enquiry carried out by
Edward I into the conduct of judges, many were dismissed
and a number imprisoned.

PLATE XIV is taken from a mid 15th-century French manu-
script of Valerius Maximus. The picture is unusual in that it
shows a woman acting in court. The miniature illustrates the
story of Hortensia, a Roman matron who made a speech in the
Forum in protest against a proposal to tax the property of
wealthy women. A court is shown in session with Hortensia,
dressed like a nun and supported by her sisters, pleading on
one side of the judge, while a man, perhaps a lawyer, speaks on
the other side. In front of the judge, a seated clerk keeps the
record; on his desk are a pencase, inkwell and an open book,
together with a rectangular wax tablet in a frame, used for
making rough notes. The men in the foreground are ushers,
who kept order in court and escorted witnesses in and out.

Medicine

In contrast to the recognised qualifications of modern doctors
and dentists, the knowledge and experience of members of the
medieval medical profession varied enormously. University-
trained physicians were in a minority. A certain level of
education was necessary to use medical text books, which were
in Latin until vernacular works became available in the 14th
and 15th centuries, and it was possible for a priest to be a
physician. However, the church, taking the view that dealings
with the flesh were not advisable for the clergy, forbade men in
major orders to carry out even minor surgery. Much training
was gained by apprenticeship and this was vital where surgery
was involved. Although surgery was taught at some universi-
ties, for example at Salerno, it was essential to receive practical
instruction, ideally as assistant to a skilled man. Barbers
frequently carried out minor operations, and a surgeon practis-
ing in London in the later middle ages would have belonged to
the gild of Barber-Surgeons. The company was naturally con-
cerned about unskilled practitioners. Moreover, in 1415, the

City authorities were worried that some barbers, inexperienced in surgery, maimed their patients rather than curing them. Subsequently, the Barber-Surgeons agreed with the mayor and aldermen that two trustworthy members of the company should be appointed to inspect the credentials of all barbers practising surgery, and further, that no member should treat a serious case without consulting the inspectors.

The battle against the quack was a running fight. In 1382 Roger Clerk of Wandsworth was tried by the mayor and aldermen of London. Representing himself as a physician, he had obtained an advance payment from a man to cure his wife of a fever. Roger then wrote upon a piece of parchment, wrapped the parchment up in cloth of gold and hung it around the woman's neck. The suspicious husband produced the parchment in court, where Roger claimed that it bore a powerful Latin charm against fever. Bad as this was, worse was to follow: Roger was in fact illiterate and had simply scribbled upon the parchment. Clerk was condemned to stand in the pillory, with 'urinals' hung before and behind him. These vessels were either urine jars, or jordans, constantly used by the physician in the course of his work, or chamber pots, perhaps considered more appropriate for a medical fraud.

Examination of urine was the medieval physician's standard diagnostic skill. It was believed that the body was composed of four humours: blood, phlegm, yellow bile and black bile. An excess of any of these humours led to illness, and one of the ways of diagnosing illness was to study the colour and consistency of the patient's urine. A miniature illustrating a chapter on the parts of the human body (Fig. 62) from a copy of Bartholomaeus Anglicus, shows an apprehensive-looking patient with two Doctors of Physick. Both doctors are wearing long gowns, to show their high academic status; one holds a flask of urine, while the other carries a beaker of blood. Observation of blood, including the way in which it flowed and clotted, was another method used in making diagnoses.

Blood-letting was not only used in diagnosis but was a popular form of treatment, since it was believed that bleeding released the humours causing sickness. In cases of serious illness, however, it is probable that the blood-letting made

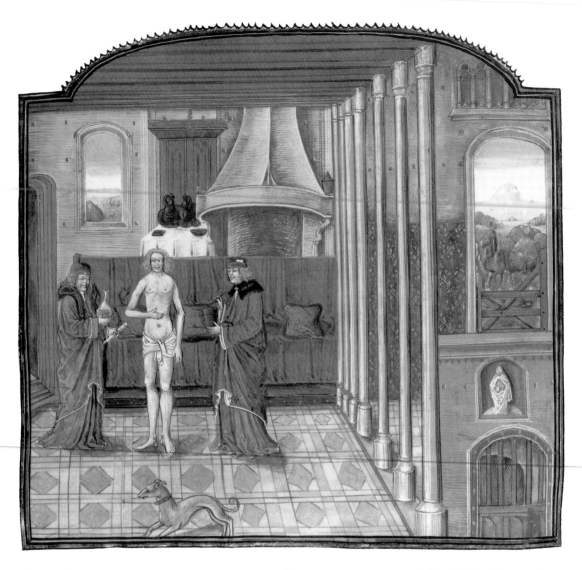

Fig. 62 Physicians.
Bartholomaeus Anglicus,
Des proprietez des choses.
Bruges; 1482.
Royal MS 15 E II, f. 77 verso

matters worse and even at times proved fatal. Blood was taken from different parts of the body depending on the illness to be treated, and the calendar was also consulted, to find the most auspicious day and hour for treatment. The most common place to make the incision was just above the elbow (Fig. 63). The patient in this illustration looks remarkably cheerful, perhaps confident that the stream of blood flowing into the bowl on the ground will effect a cure. The miniature occurs in a copy of *Li Livres dou santé* ('Books of health') of Aldobrandino of

116

Fig. 63 Blood-letting.
Aldobrandino of Siena,
Li livres dou santé. France;
late 13th century.
Sloane MS 2435, f. 11 verso

Siena, a manual of advice on diet and health. The manuscript was written in France in the late 13th century.

Medical treatises illustrate the range of surgical operations available. For example, a manuscript of the *Chirurgia* ('Surgery') of Roger Frugardi of Parma contains a series of pictures showing the stages of an operation for fracture of the skull. However, such complex work could only have been done by a surgeon of considerable skill. The same manuscript, which was executed in France in the early 14th century, also contains illustrations of treatment for dislocated limbs. The surgeon shown in Fig. 64, distinguished by his long, sleeveless gown and cap, is treating a dislocated elbow: he holds the patient's forearm firmly upright, while exerting pressure on the joint by means of a sling and his right foot.

The ancient art of treating sickness with medicines prepared

from natural ingredients was practised by apothecaries as well as by physicians, and most towns must have had an apothecary's shop, where medicines and ointments could be bought over the counter as in a modern chemists. Herbs could be used on their own, or combined with other natural ingredients. Fig. 65, a marginal drawing from another manuscript of the *Chirurgia* of Roger Frugardi, made in England in the mid 13th century, shows a doctor supervising the preparation of medications by his assistants. The doctor sits with a bowl of ingredients at his feet and a pair of scales in his hand. One of his assistants is pounding materials with a pestle and mortar, while the other stirs a mixture in a large bowl over the fire. Between the two stands a basin containing four small jars. Medicines were also made by combining or separating elements, usually by application of heat. For example, alcohol was extracted by distilling wine. The wine was heated over a furnace until the alcohol vapourised: then the vapour was drawn off through a tube and, on cooling, it returned to liquid form.

Distilling was just one process used by alchemists which was also employed to make medicine. In the course of his experiments, the alchemist attempted to change the nature of materials, and in particular to turn base metals into gold and silver. An illustration from a copy of the *Ordinal of Alchemy* of Thomas Norton, the 15th-century Bristol alchemist (Fig. 66) shows stills and other vessels heating on seven furnaces, tended by two assistants; this English manuscript was executed around 1490. In addition to the unsuccessful search for

Fig. 65 Making
medicines.
Roger Frugardi, *Chirurgia*.
England; mid 13th
century.
*Trinity College Cambridge
MS 0.1.20, f. 241 verso*

Fig. 66 Alchemists. Thomas Norton, *Ordinal of Alchemy*. England; about 1490.
Additional MS 10302, f. 1

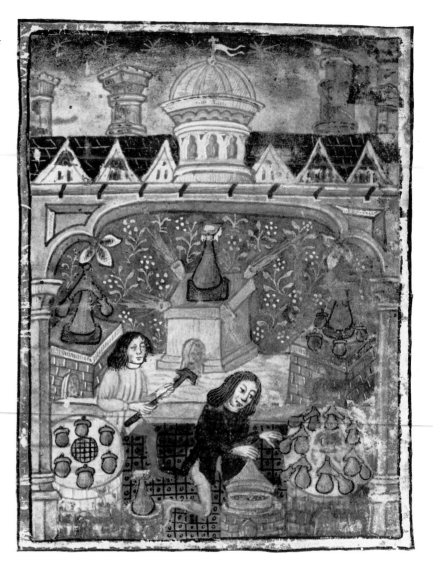

gold, there was another aspect of the work of the alchemist, the quest for the elixir of life or the philosopher's stone. Perhaps the prospect of a son taking up alchemy as a profession did not wholly commend itself to the practical father who hoped to see his children get on in the world.

Select bibliography

General

J. M. Backhouse, *Books of Hours*, 1985

D. Hartley, *Life and work of the people of England*, vols. i–iii, 1925–1931

H. T. Riley, ed., *Memorials of London and London Life*, 1868

C. Singer, ed., *A History of Technology*, vol. ii, 1956

Chapter I

H. S. Bennett, *Life on the English Manor*, 3rd ed., 1948

R. Bennett and J. Elton, *History of Corn Milling*, vol. ii, 1899

D. Hartley, *Food in England*, 1954

J. Harvey, *Mediaeval Gardens*, 1981

P. D. A. Harvey, *A medieval Oxfordshire village: Cuxham 1240–1400*, 1965

R. H. Hilton, *A medieval society. The West Midlands at the end of the thirteenth century*, 1966

J. Langdon, *Horses, oxen and technological innovation*, 1986

R. Lennard, *Rural England 1086–1135*, 1959

D. Oschinsky, ed., *Walter of Henley and other treatises on estate management and accounting*, 1971

R. Trow-Smith, *A History of British Livestock Husbandry to 1700*, 1957

Chapter 2

L. F. Salzman, *English Trade in the MiddleAges*, 1931

G. A. Williams, *Medieval London from Commune to Capital*, 1963

Chapter 3

A. R. Bridbury, *England and the Salt Trade in the later Middle Ages*, 1955

T. F. Reddaway and L. E. M. Walker, *The Early History of the Goldsmiths' Company 1327–1509*, 1975

L. F. Salzman, *Building in England*, 1952

L. F. Salzman, *English Industry in the later Middle Ages*, 2nd ed., 1923

Chapter 4

J. H. Baker, *An introduction to English Legal History*, 1971

V. W. Egbert, *The medieval artist at work*, 1967

P. Heath, *The English Parish Clergy on the eve of the Reformation*, 1969

P. M. Jones, *Medieval Medical Miniatures*, 1984

D. Knowles, *The Monastic Order in England*, 1941

D. Knowles, *The Religious Orders in England*, 3 vols, 1957–1960

J. Lawson, *Medieval Education and the Reformation*, 1967

H. Rashdall, *The Universities of Europe in the Middle Ages*, 3 vols, 2nd ed., 1936

D. C. Lindberg, ed., *Science in the Middle Ages*, 1978

Index